The Adirondacks

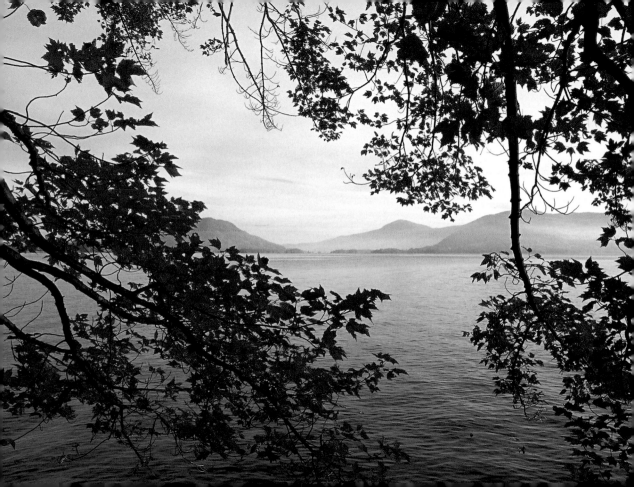

The Adirondacks

CARL HEILMAN II

RIZZOLI
NEW YORK

Contents

6 INTRODUCTION

8 CHAPTER ONE
Lake Placid and the High Peaks

60 CHAPTER TWO
Eastern Lakes, Wilds, and Farmlands

116 CHAPTER THREE
Central and Southern
Waterways and Mountains

170 CHAPTER FOUR
The Boreal North

224 ACKNOWLEDGMENTS

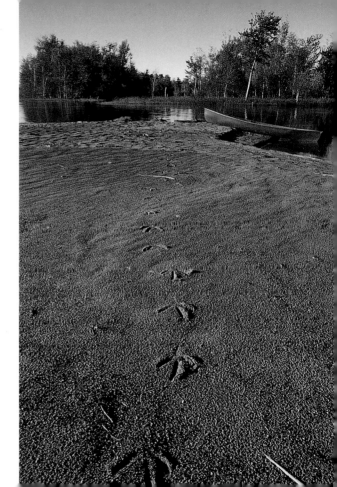

Introduction

I FELL IN LOVE with the Adirondack mountains years ago on the summit of Algonquin on a blustery January day. Ice and snow fragments stung exposed skin on my cheeks and forehead as the near-hurricane-force winds roared around my body. I leaned forward on the rocky ridge and stretched my arms out for support on the southern winds blasting over the peak and embraced the beauty, freedom, spirit, and wildness of these rugged mountains.

I've been exploring the Adirondacks since the summer of 1973—hiking, canoeing, snowshoeing, skiing, and bushwhacking to every corner of the park. The amazing part of this journey is that with each new location I visit, I find many more new places to explore. Some locations I've visited numerous times, and each time the light and weather conditions offer beautiful new perspectives on the landscape. While there are numerous wonderful views from the lakes and roadways, the mountaintop vistas offer the best perspective of the vast wildness of the Adirondack Park.

From the tops of a number of the highest peaks it's possible to see into almost every corner of the six-million-acre Adirondack Park. The magnificence and magnitude of the Adirondacks can be quite overwhelming. In a constitutionally protected park that is larger than several of New York's neighboring states, there are more than 2,800 lakes and ponds, more than 30,000 miles of streams and rivers, and 42 mountain peaks greater than 4,000 feet in elevation. Lake Champlain, on the eastern park boundary is 95 feet above sea level. Precipitous palisades rise from the lake's shoreline at Split Rock Mountain, and the landscape continues to rise to the 5,344-feet summit of Mount Marcy in the center of the High Peaks region, only 25 miles away.

The beauty of the Adirondack region is found in this spectacular combination of crystalline waters and forested mountains, wildflowers and fall foliage, and mossy bedrock and mountaintop islands of alpine tundra. The balance here is a delicate one. It's a balance between the desire of people to live on private land within the park and the desire to keep a sense of wilderness in the region. It's also a balance between issues of free access for people to enjoy the wild landscape and the issues of people overusing and destroying sensitive habitats, the influx of invasive species, and water and air pollution. Regional attractions such as The Wild Center in Tupper Lake and the Visitor Interpretive Centers in Paul Smiths and Newcomb help current generations understand the effort needed to maintain this balance for future generations.

Fairly central in the Adirondack Park are the Adirondack High Peaks. One of the most popular regions in the Adirondacks, the High Peaks region includes the wild beauty of the Lake Placid and

Whiteface Mountain area. Views of and from the mountains are some of the finest in the world, with spectacular 360-degree vistas of the adjacent mountains and lakes. Some of the best trophy trout fishing in the state is found here in the waters of the Ausable River that flow from the cool forested valleys of the highest mountains in New York. This area is a year-round host to world class events including Ironman triathlons and winter Olympic sports.

The eastern Adirondacks are a mix of rolling farmlands and wild foothill mountains in the Champlain Valley, Schroon Lake, and Brant Lake regions. Lake George, the island-studded Queen of American Lakes, is flanked by rugged mountains along most of its 32-mile length. European history in this region began in 1609 when Samuel Champlain discovered a 125-mile-long lake and named it after himself. This is the same year Henry Hudson explored the Hudson River coming from the south as far north as Albany. In the 1700s this corridor played a major part in the French and Indian War and the Revolutionary War.

The southern and central Adirondack regions include Prospect, Hadley, Kane, and Blue Mountains—with views that reach to the High Peaks, the Great Sacandaga Lake, Lake Pleasant, Indian Lake, Piseco Lake, Caroga Lake, and the Old Forge area. In this region can be found old-growth pines, beautiful cascades and waterfalls, enormous expanses of trailless Adirondack wilderness, and Snowy Mountain—the highest peak outside of the High Peaks region. The interconnected Adirondack waterways of the Fulton Chain of Lakes, Raquette Lake, and charming Blue Mountain Lake are a real draw for summer tourists.

Most of the northern Adirondacks are a boreal forest of spruce, balsam, and larch, with a mix of foothills, lakes, waterways, and bogs. Tupper Lake, Lake Lila, the Bog River Flow, the Saranacs, the Saint Regis Wilderness Canoe Area, Massawepie Mire, Spring Pond Bog, the Sable Mountains, and Chazy Lake are just a few of the wonderful natural attractions in this region. Here the wild Adirondack waters flow to the north and west off the great Adirondack dome to meet up with the St. Lawrence River.

Years ago when I started exploring the diversity of the Adirondacks, I quickly developed a passion for photographing the varicolored palette of the rugged yet delicate wilderness. Nature is the ultimate sculptor and artist. As a photographer I work to interpret the beauty and life of a three-dimensional landscape on a flat surface. Sometimes I carefully isolate details of a view, while other times I work in spacious vistas with composition and lighting to help evoke a sense of three dimensions in a two-dimensional photograph.

Photographing the Adirondacks presents its own unique challenges of working with regional weather to put myself into specific conditions at precisely the right moment to capture the subtle nuances of Adirondack light and landscape on film. Nature photography comes from my heart as a way to help communicate the sublime beauty of these mountains and lakes. My goal is to draw people into the wonder of these wild untamed areas where we can once again—even if only for a brief time—become one with the spirit of the natural world.

—CARL HEILMAN II

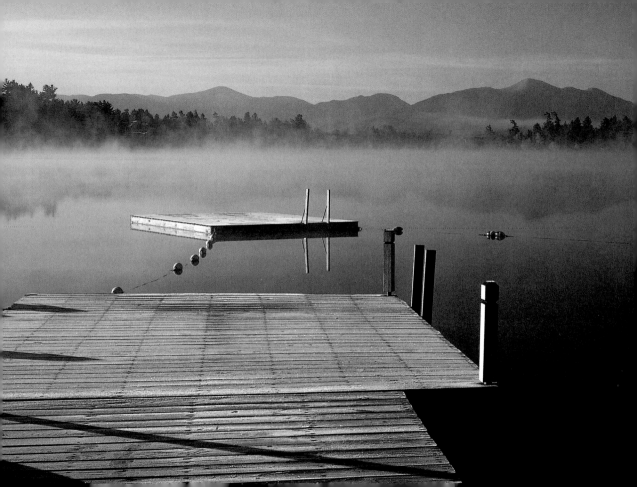

Lake Placid and the High Peaks

❧

Tahawus, Mount Marcy, Algonquin, Marcy Dam, Avalanche Pass, Flowed Lands,

Heart Lake, Cascade, Noonmark, Keene Valley, Whiteface, Elk Lake,

Ausable River, Saint Huberts, Preston Ponds,

High Falls Gorge, Ampersand

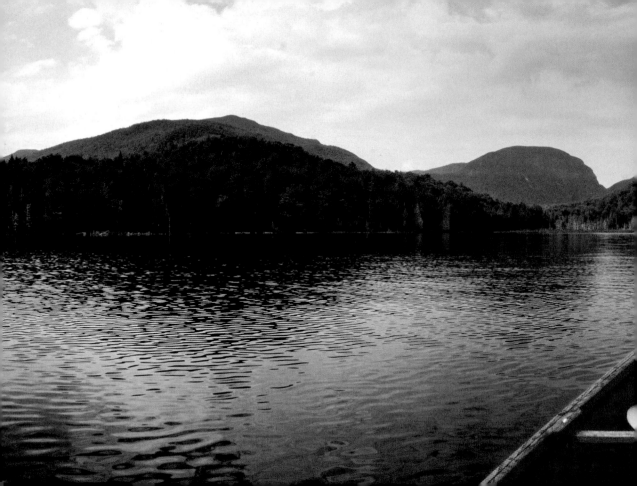

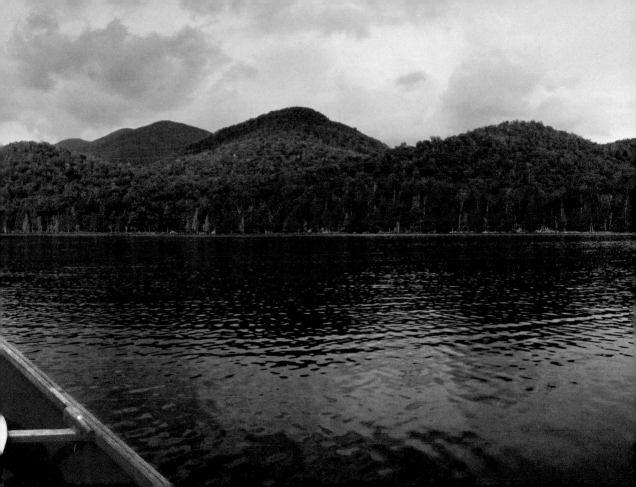

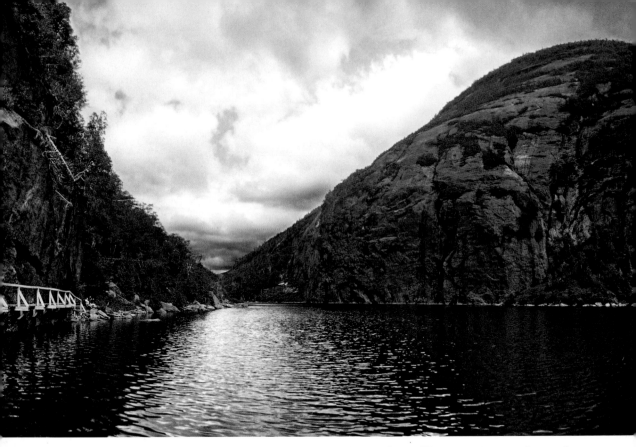

chapter opener *Mirror Lake Inn boat dock, Lake Placid* previous page *Looking north to Wallface Mountain on Henderson Lake*

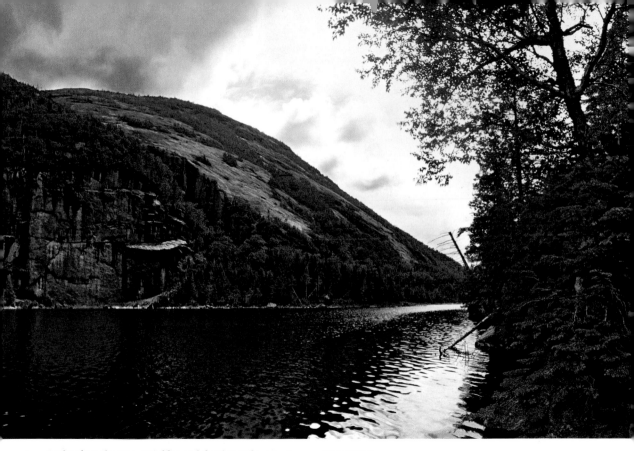

above *Avalanche Lake, Mount Colden and the Trap Dike* following page *Marcy Dam*

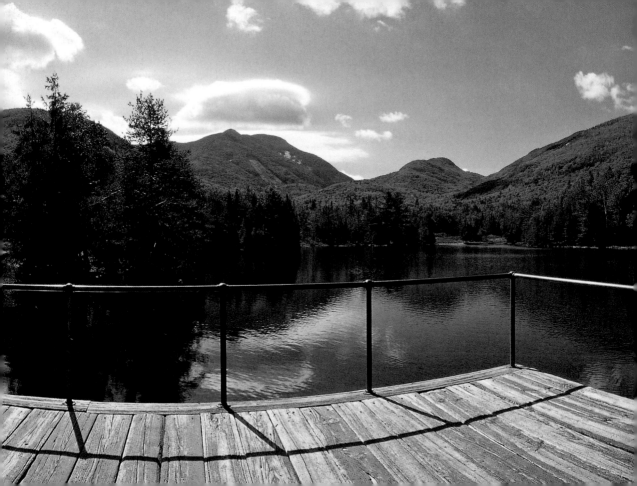

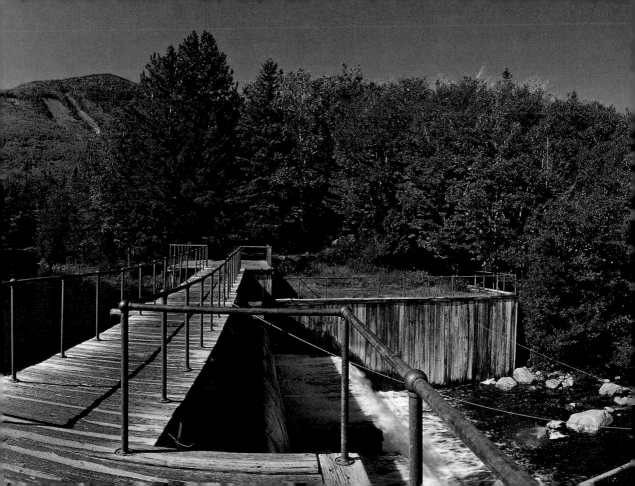

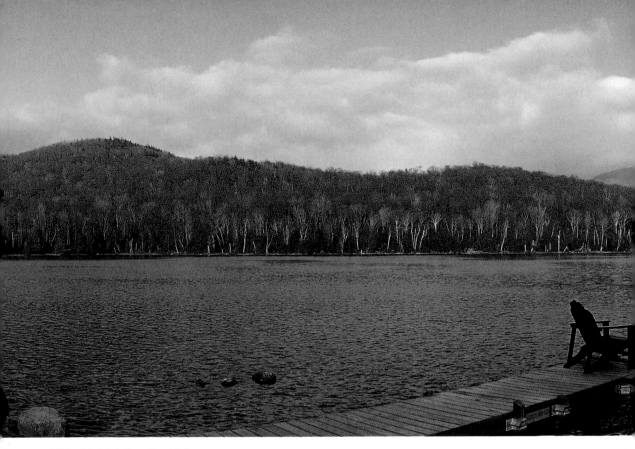

Adirondak Loj dock on Heart Lake

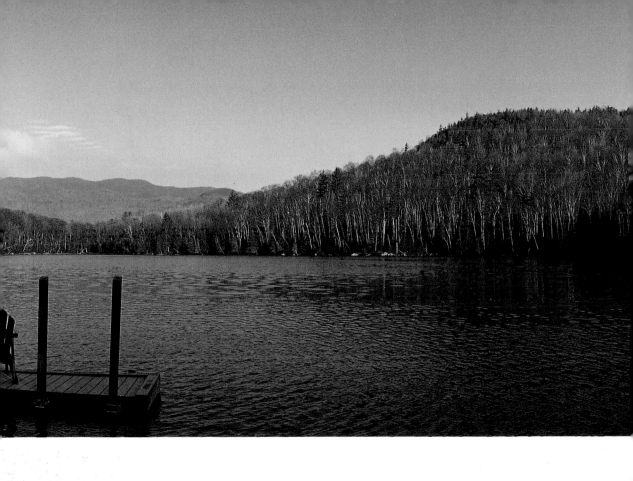

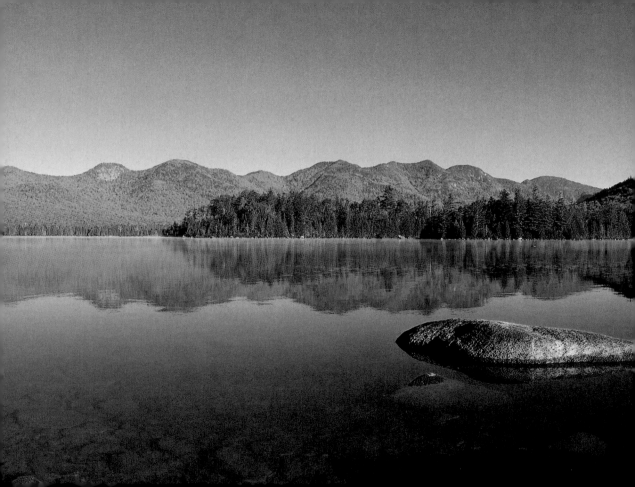

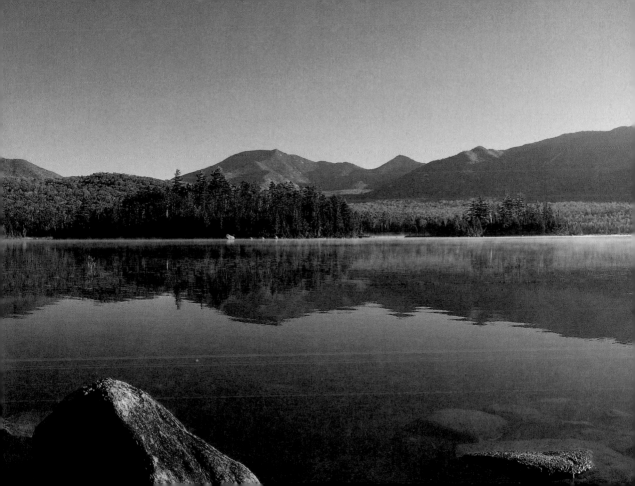

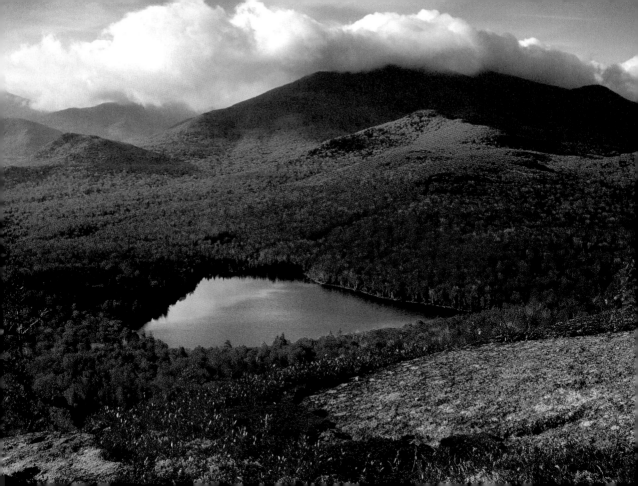

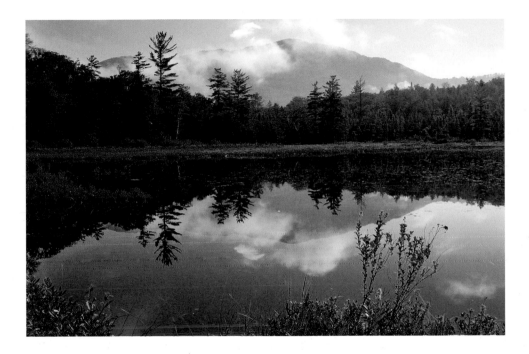

above *Mount Adams from a beaver flow north of Sanford Lake* opposite *Clouds over Algonquin and Heart Lake from Mount Jo* previous page *Elk Lake, reflections* following page *Marcy, Colden, Algonquin, and the High Peaks from Mount Van Hoevenberg*

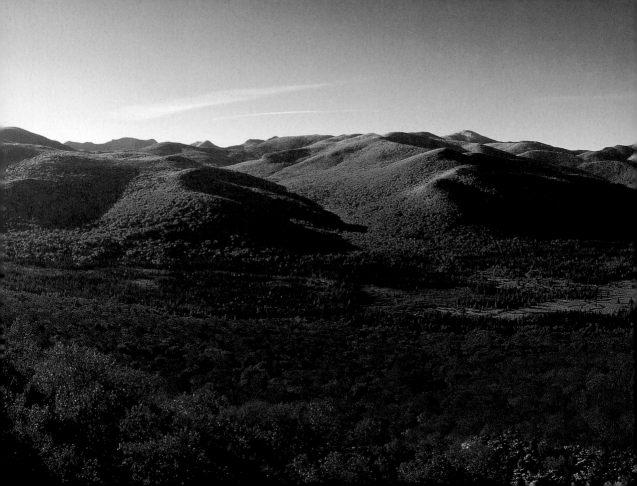

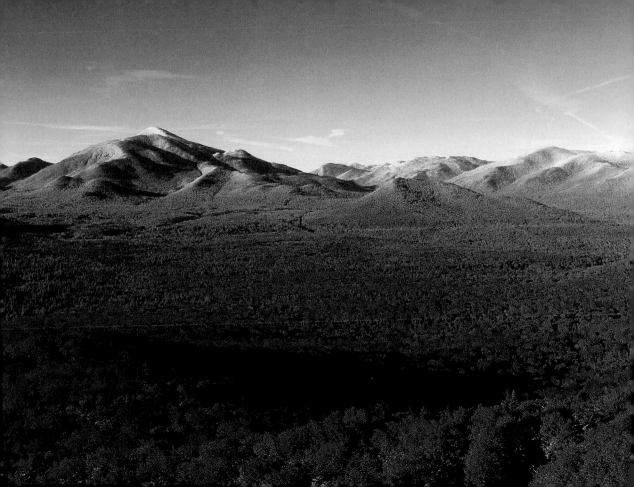

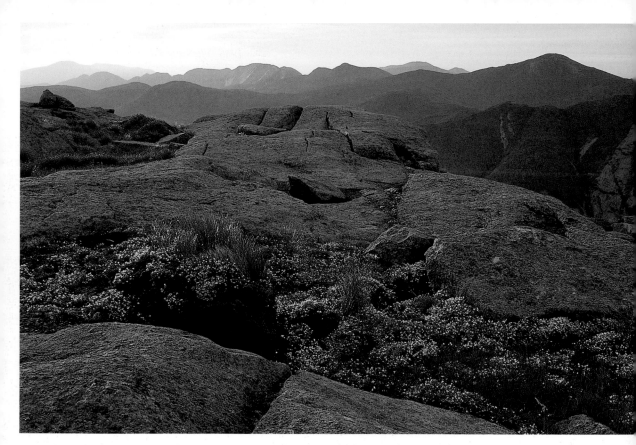

above *Mountain sandwort on Algonquin* opposite *South Meadow detail from Mount Van Hoevenberg*

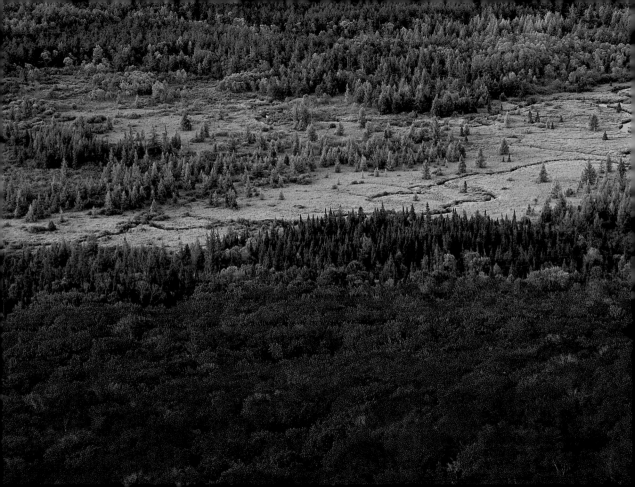

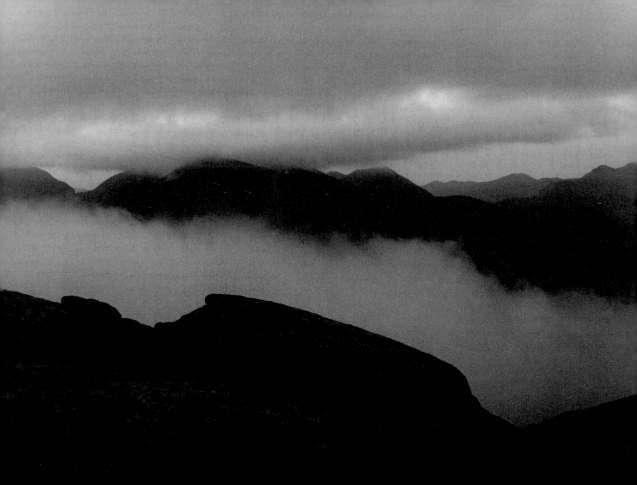

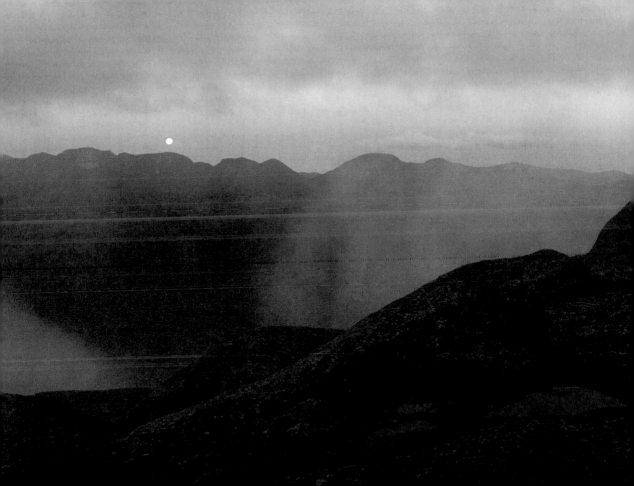

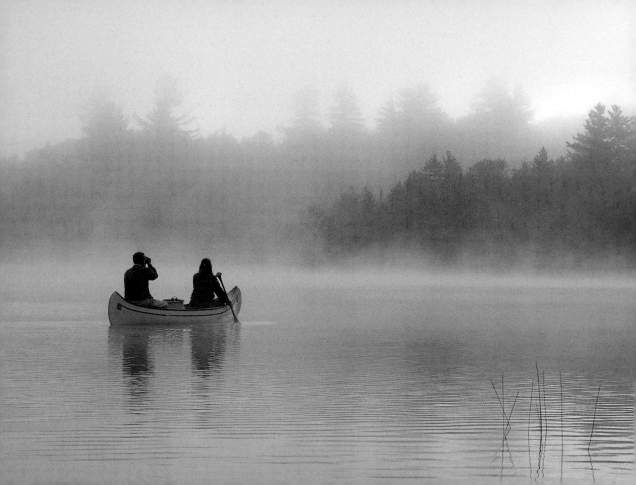

above *Foliage along the North Fork of the Bouquet River*
opposite *Morning light on Connery Pond*
previous page *Moonset behind the Great Range, from Noonmark*

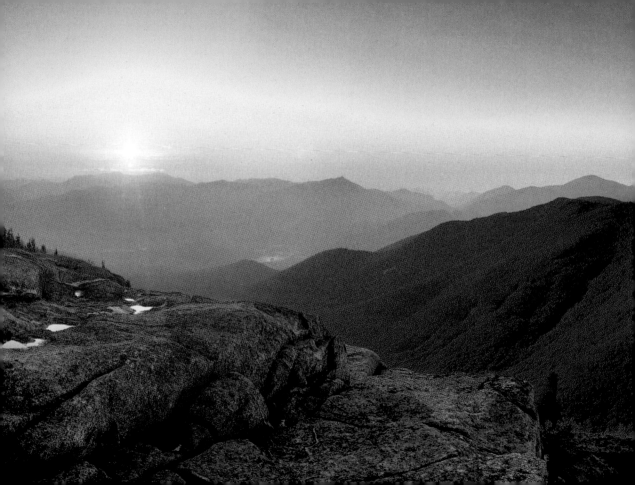

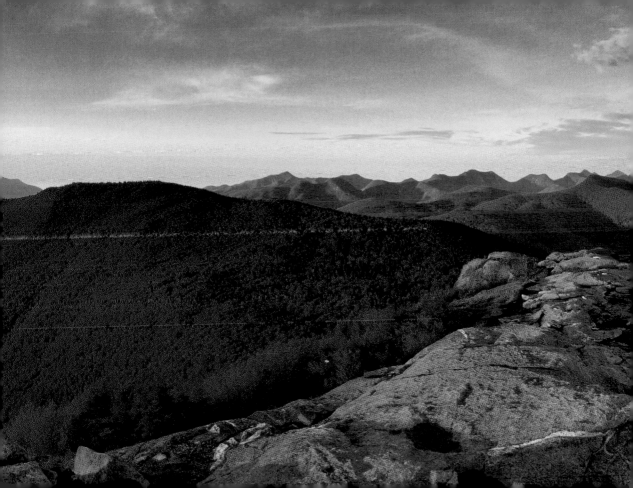

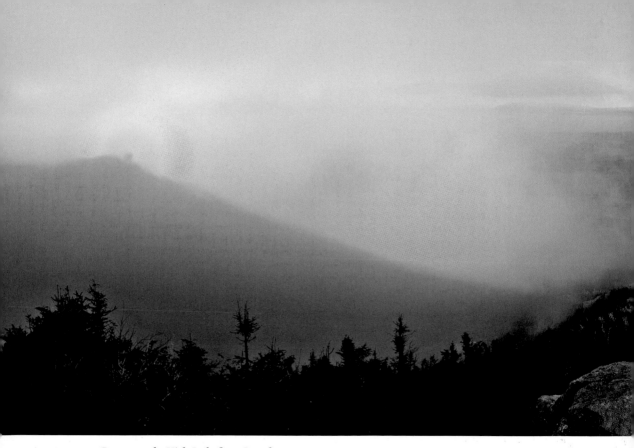

previous page *Dawn over the High Peaks from Cascade*

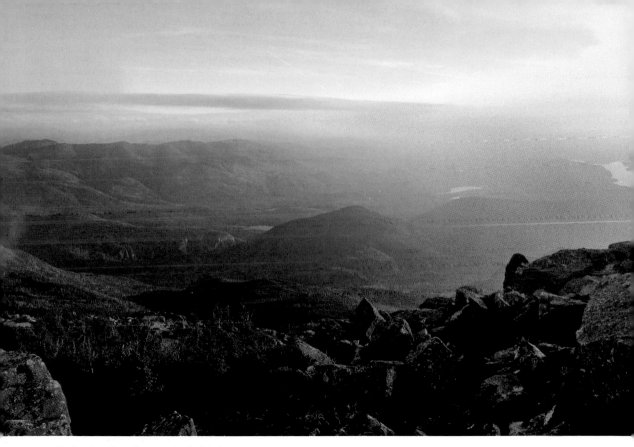

above *Ulloa's Rings from the summit of Whiteface*

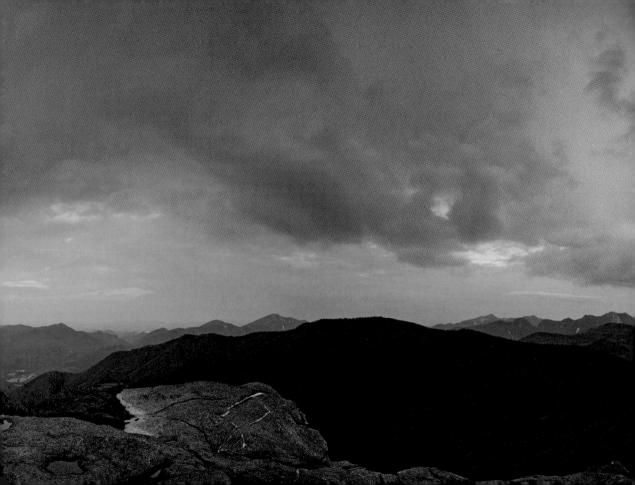

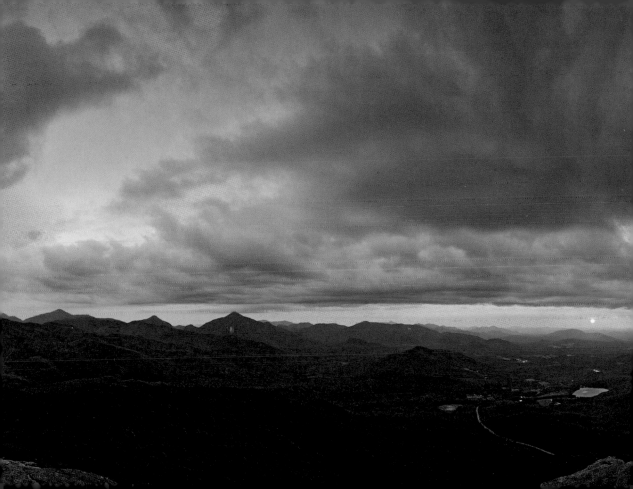

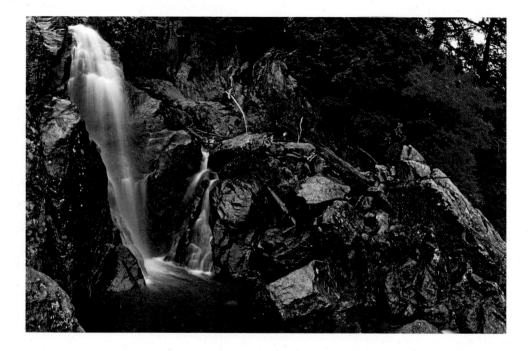

above *Roaring Brook Falls at the base of Giant* opposite *Detail at the base of Roaring Brook falls*
previous page *Sunset on Cascade*
following page *Giant, the Great Range, and the Johns Brook Valley from The Brothers*

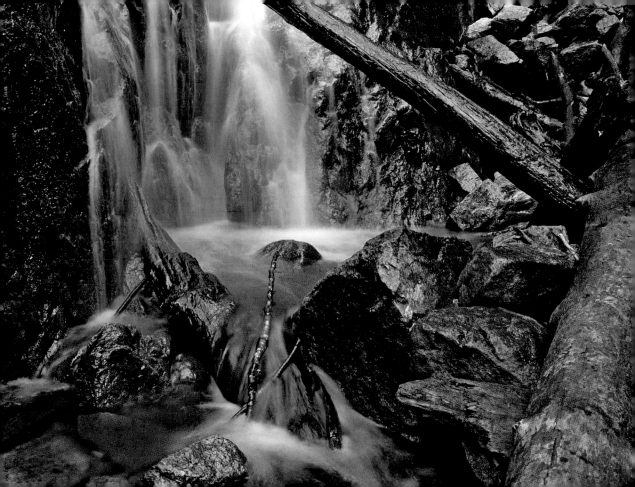

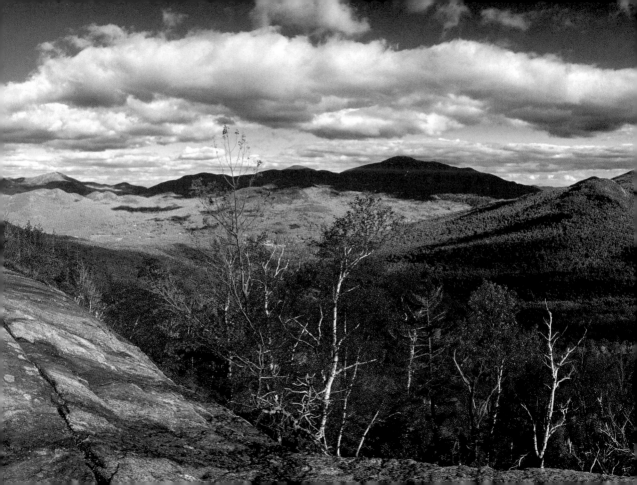

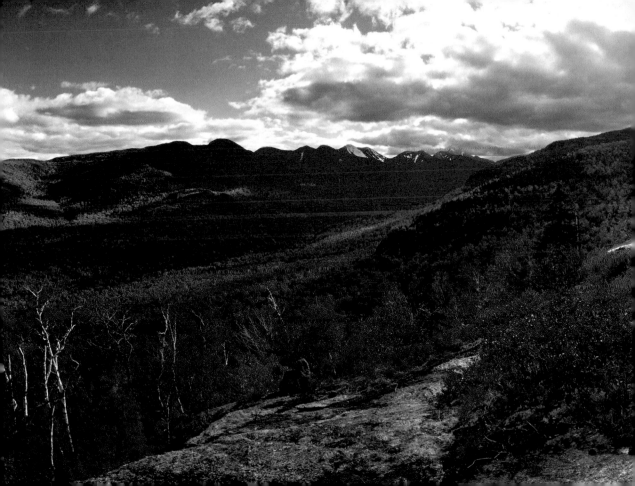

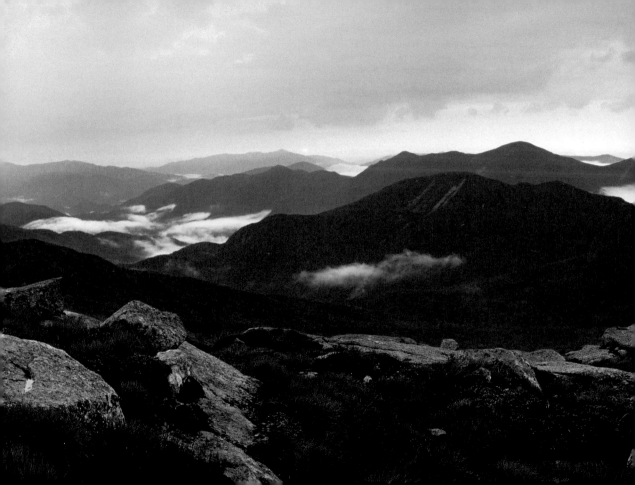

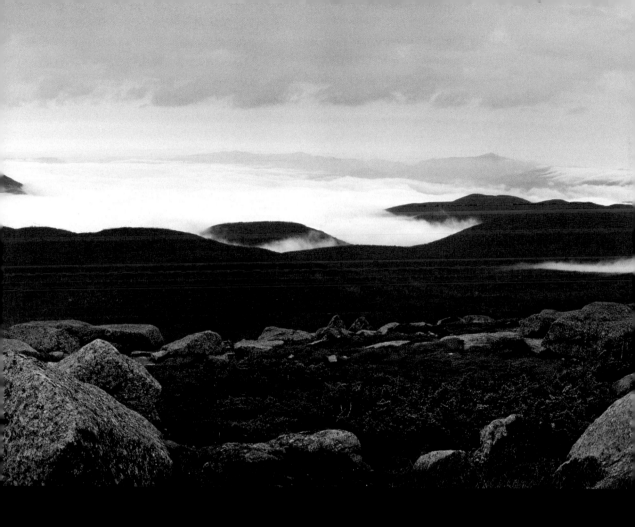

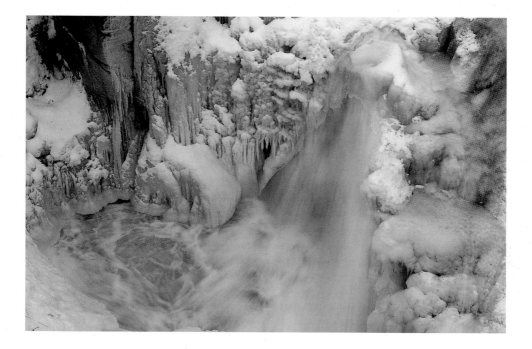

above *Flume on the Ausable River near Wilmington* opposite *Algonquin summit*
previous page *After a storm on Mount Marcy*
following page *Iroquois, Algonquin, and Colden from the Flowed Lands*

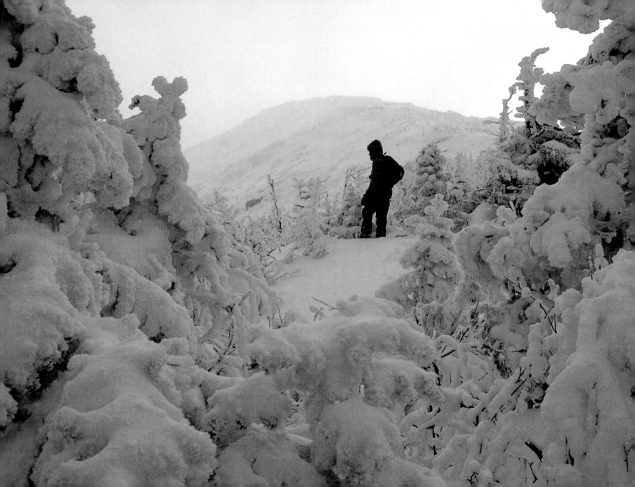

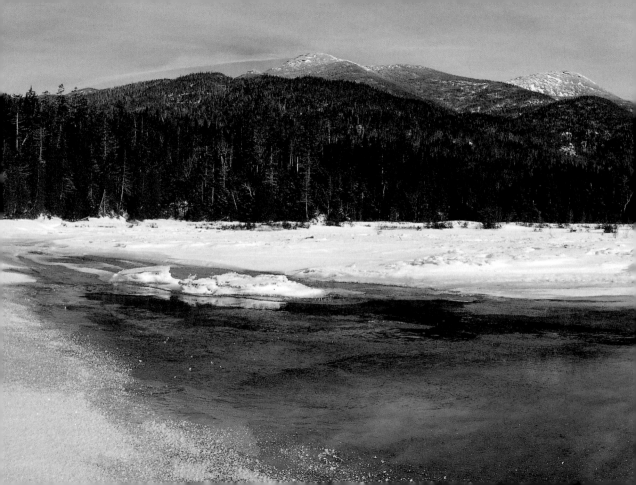

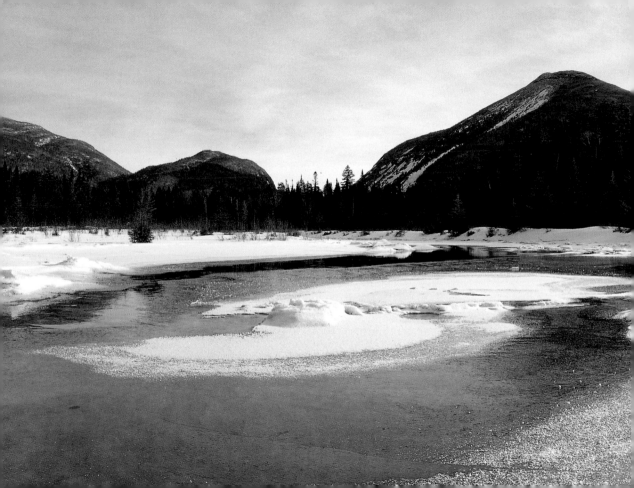

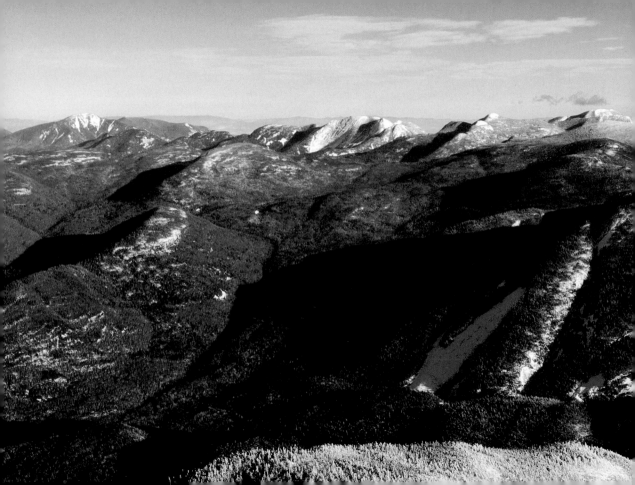

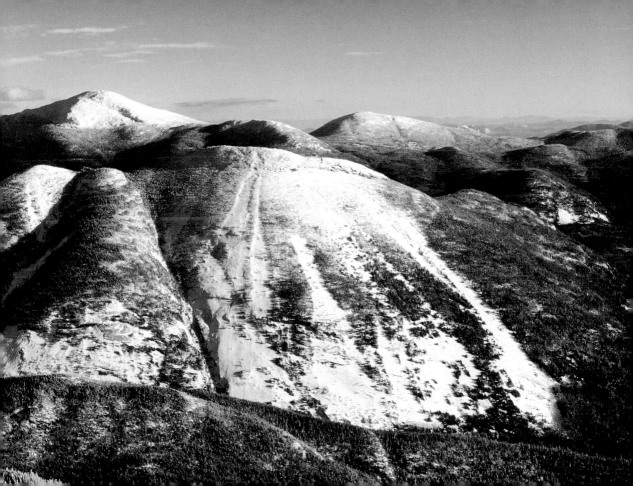

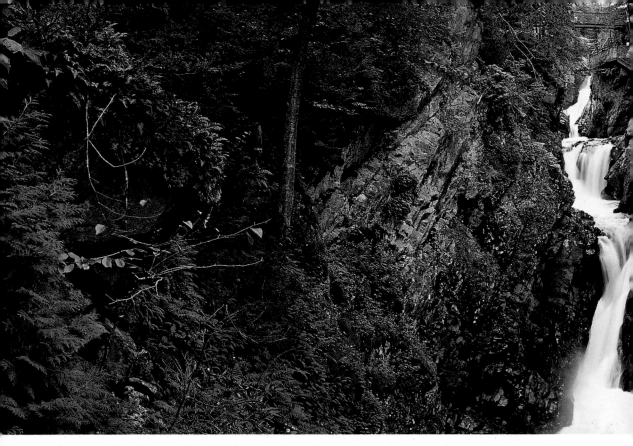

previous page *Colden, Marcy, and the High Peaks from Algonquin*

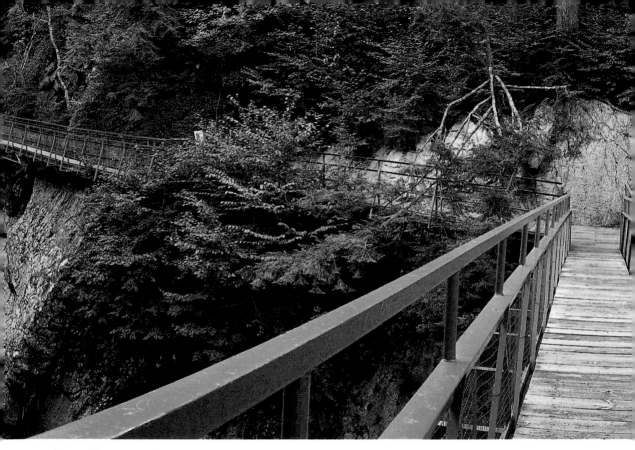

above *The Ausable River at High Falls Gorge, Wilmington*

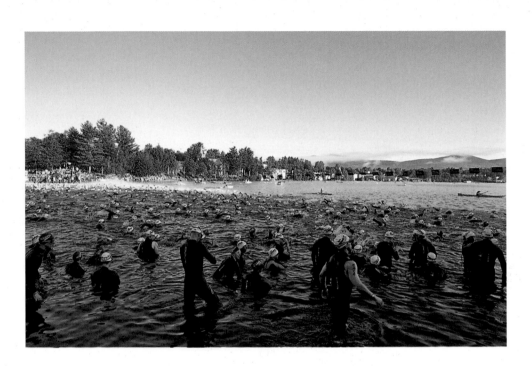

above *Start of the Lake Placid Ironman on Mirror Lake*
opposite *Lake Placid village from the Crowne Plaza Resort*
following pages *360-degree sunset from the summit of Whiteface*

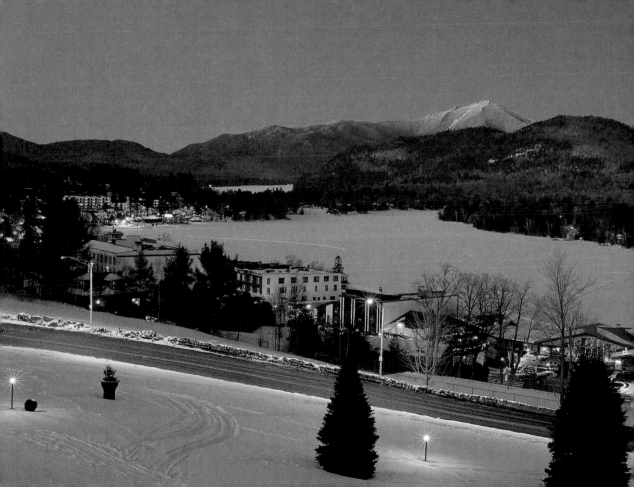

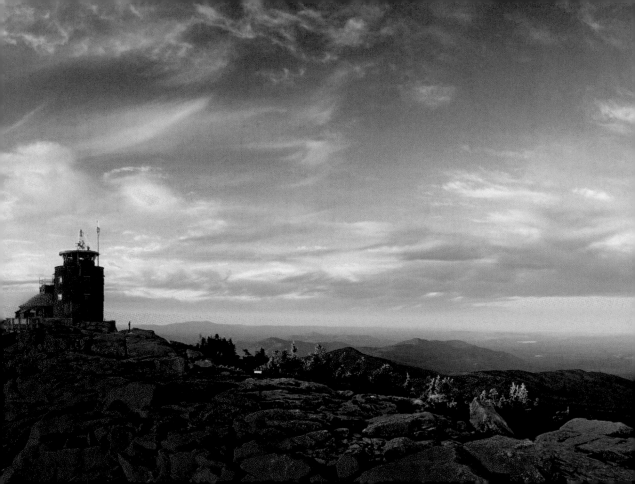

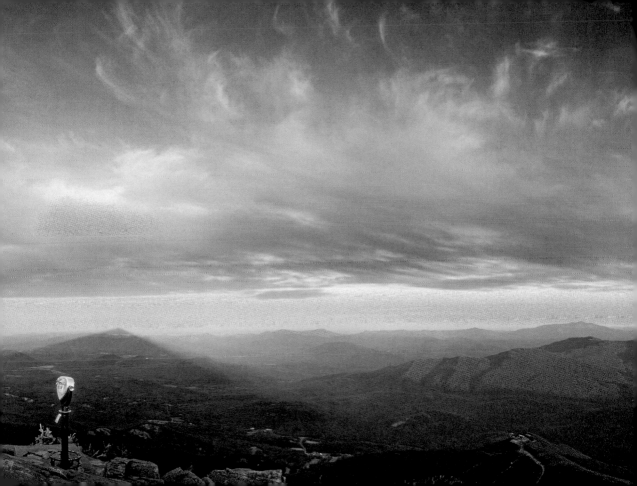

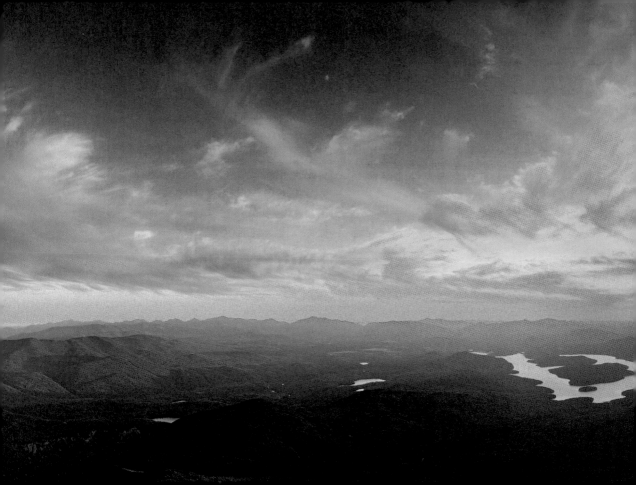

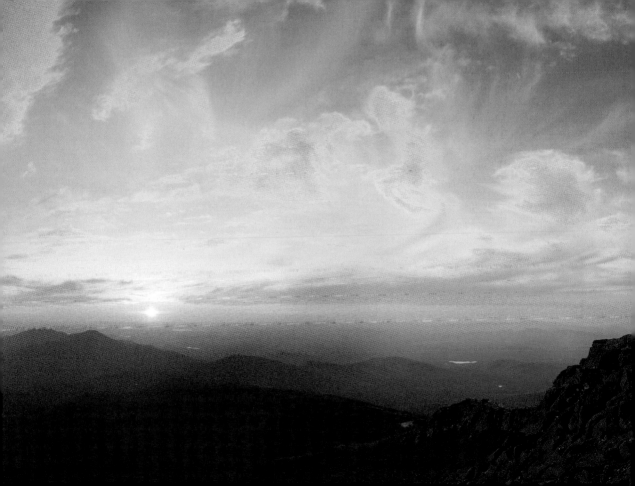

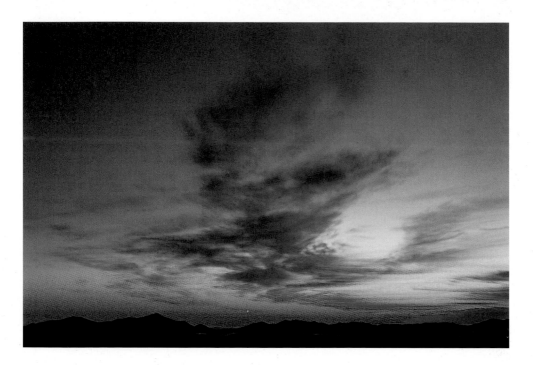

above *Sunrise behind Whiteface from Ampersand*
opposite *Lenticular cloud over Giant and the Ausable Club golf course*
following page *Morning light at Lower Preston Pond*

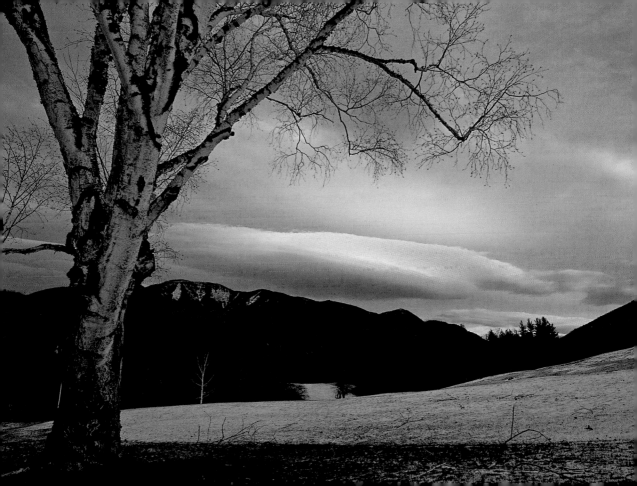

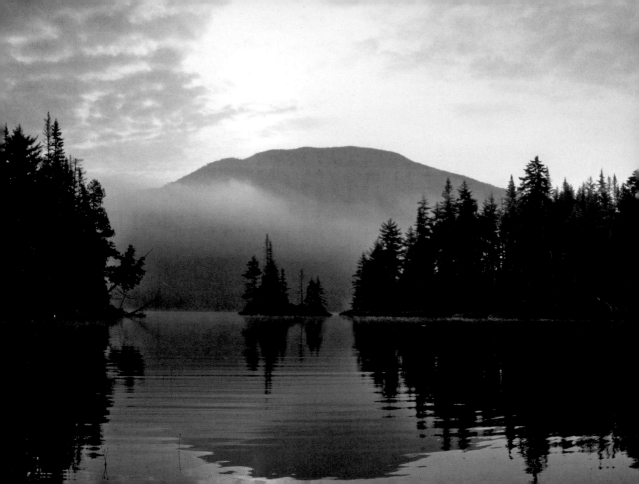

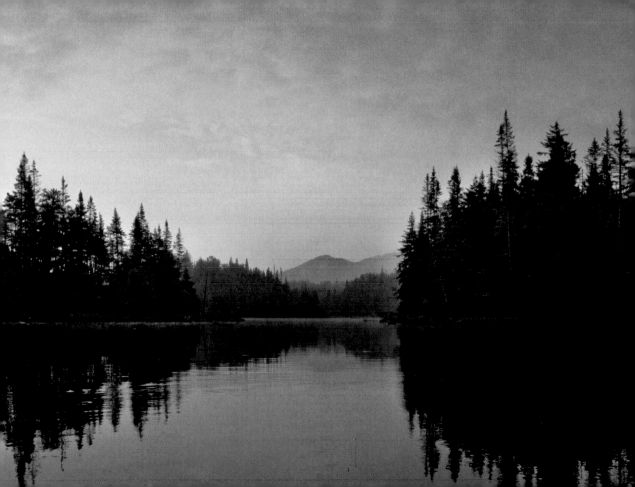

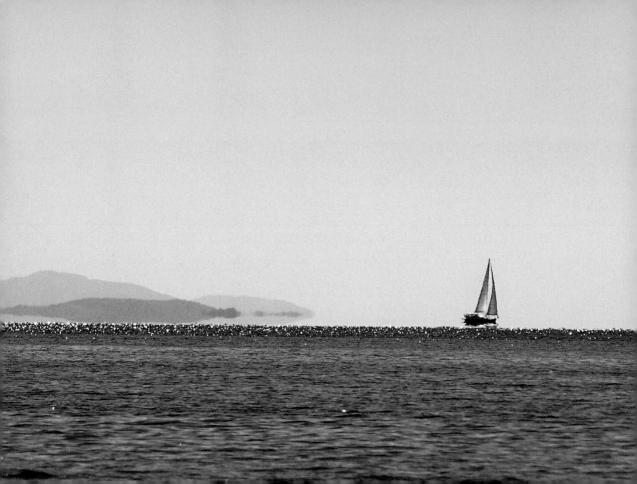

Eastern Lakes, Wilds, and Waterways

❧

Ausable Chasm, Lake Champlain, Valcour Island, Split Rock, Coon Mountain, Rattlesnake Mountain,

Westport, Essex, Port Henry, Ticonderoga, Lake George, Schroon Lake, Hoffman Mountain,

Pharaoh Lake Wilderness, Brant Lake, Loon Lake,

Friends Lake, Hudson River, Gore Mountain,

Lake George Wild Forest

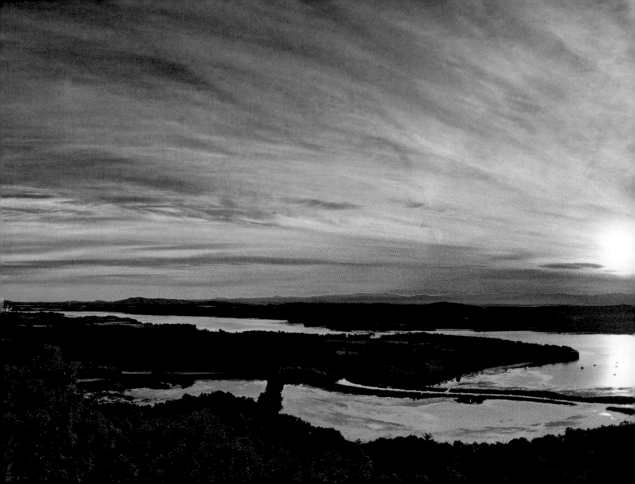

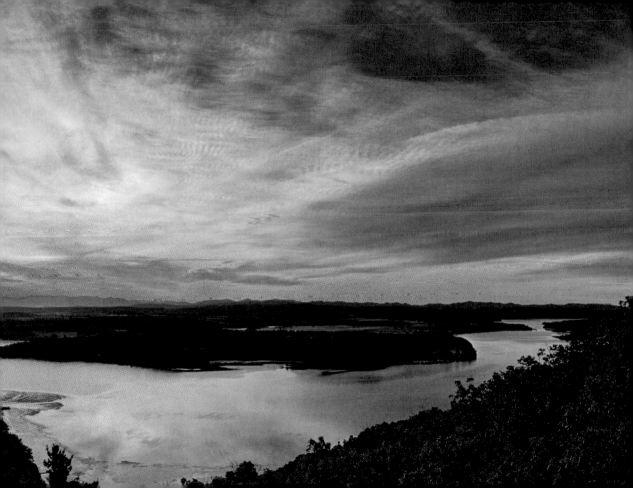

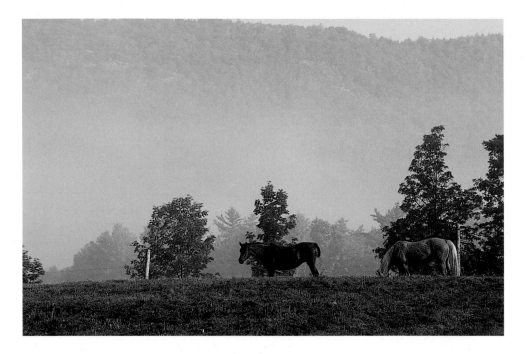

chapter opener *Looking south on Lake Champlain from Garden Island*
previous page *Fort Ticonderoga and Lake Champlain from Mount Defiance*
above *Along the road into Glenburnie south of Ticonderoga*
opposite *Champlain Valley farmlands from Coon Mountain*

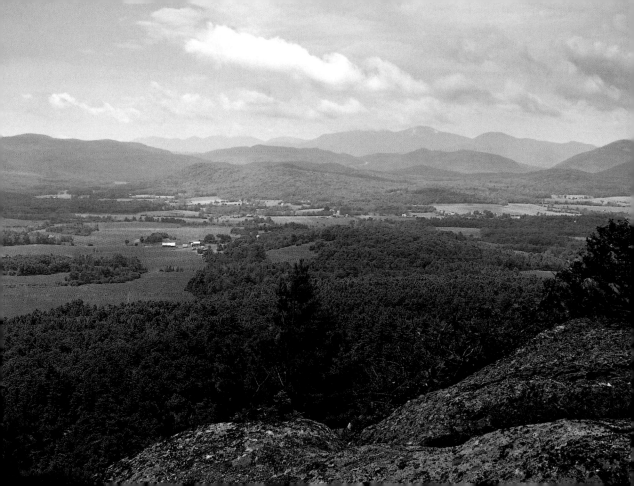

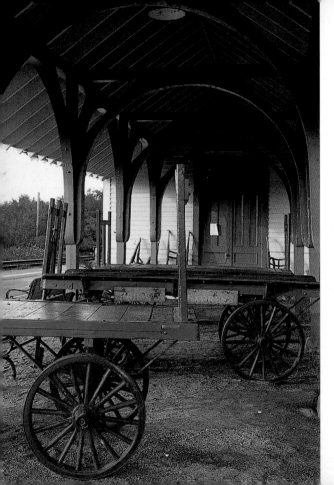

left *Westport Depot Theatre*
opposite *Champlain Valley farmlands near Essex*
following page *Lake Champlain from Valcour Island*

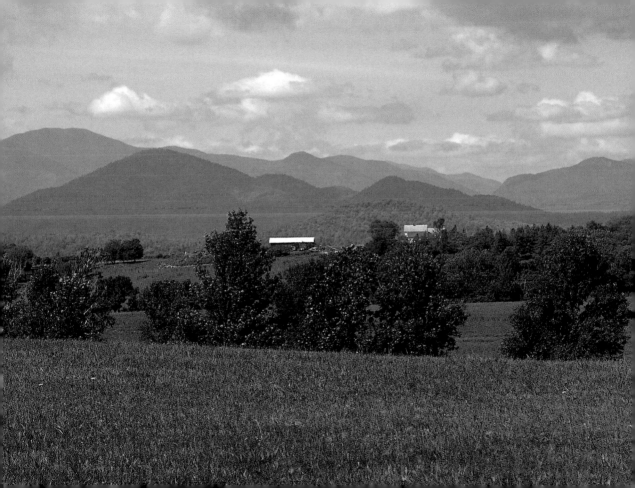

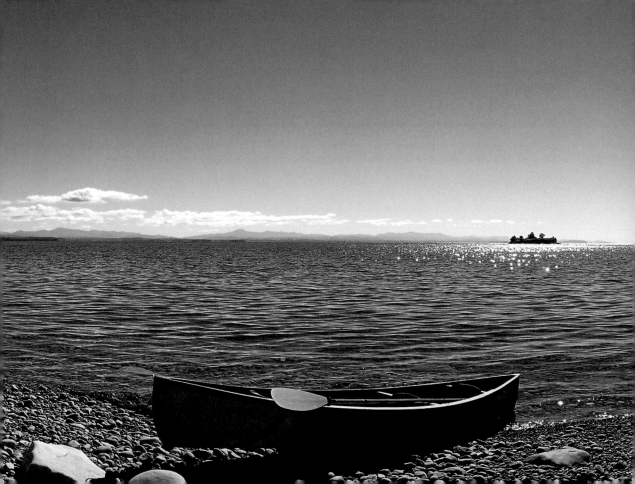

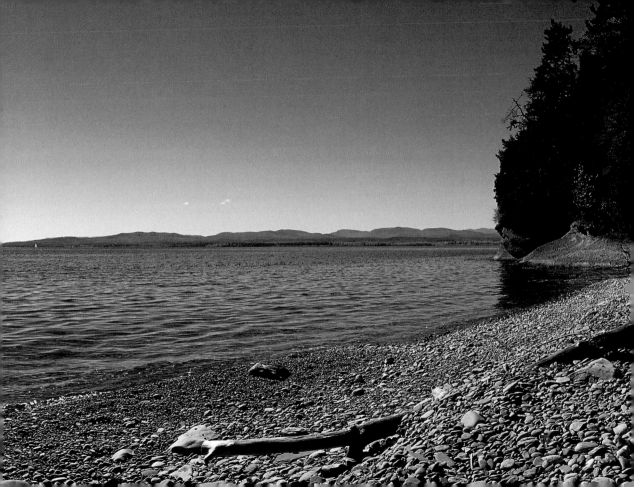

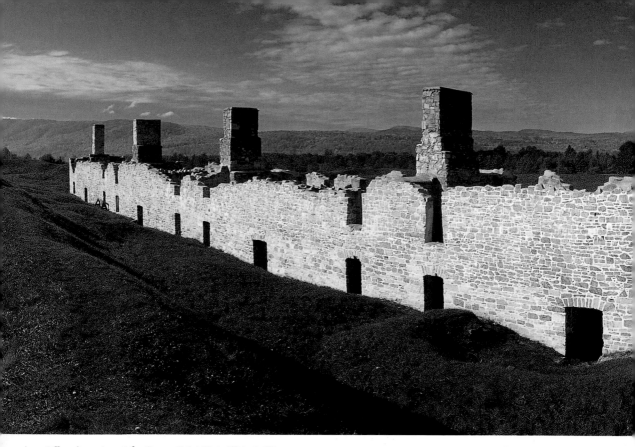

Officers' quarters at the Crown Point State Historic Site

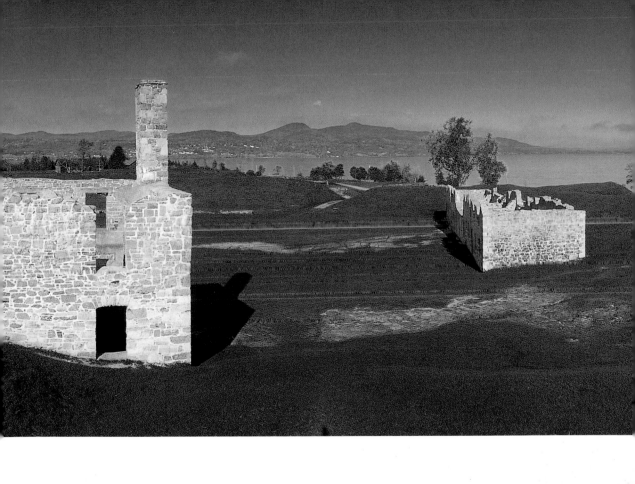

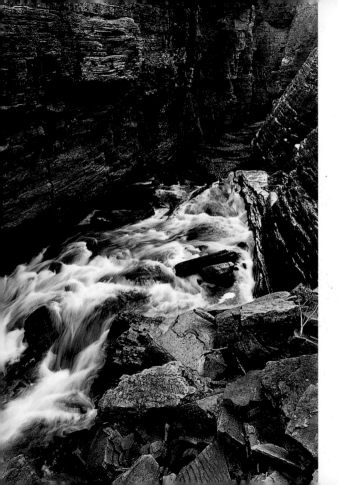

left Ausable River cascades in the depths of Ausable Chasm
opposite Ausable Chasm, the oldest natural attraction in the U.S.
following page At the mouth of the Little Ausable River on Lake Champlain

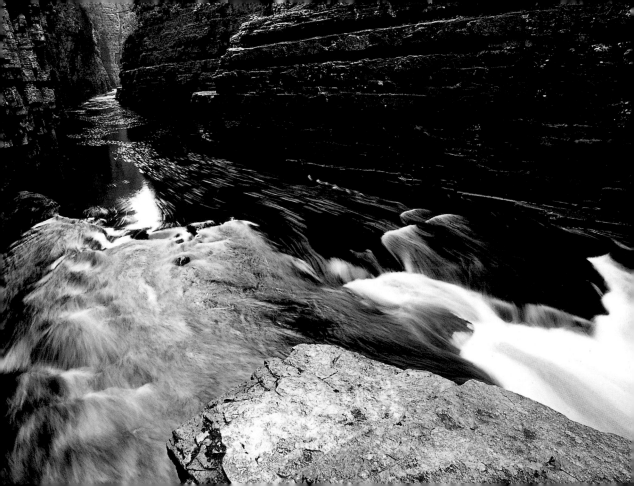

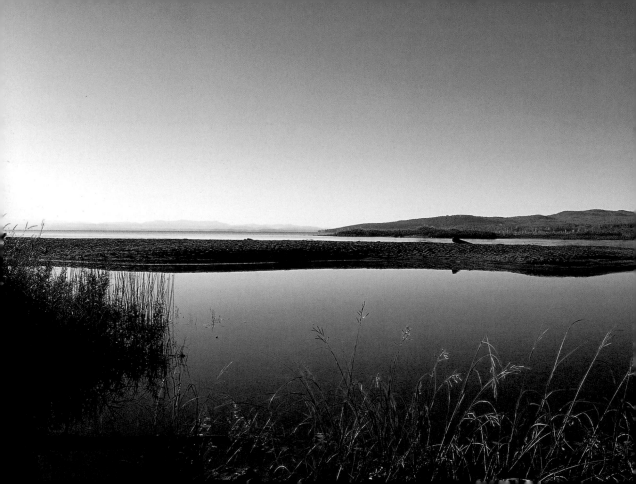

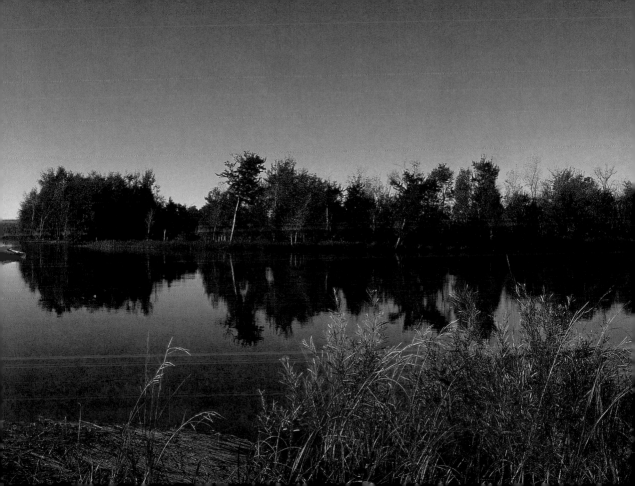

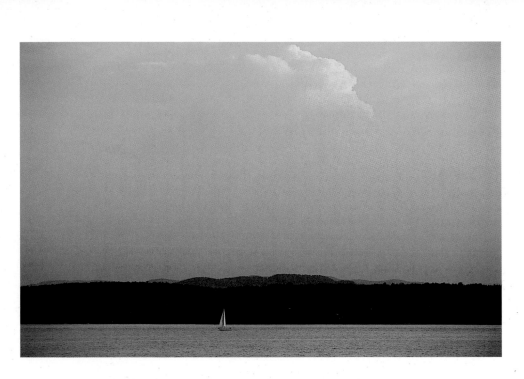

above *Sunset light from the Essex ferry*
opposite *Sunrise over Lake Champlain and Willsboro Point*
following page *Overlooking the Bolton Landing area on Lake George*

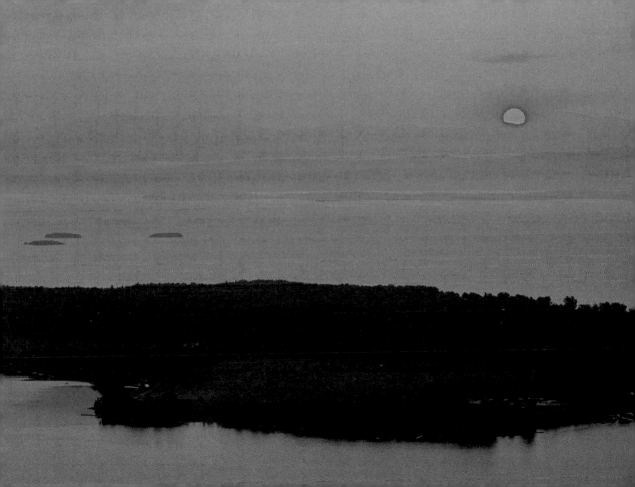

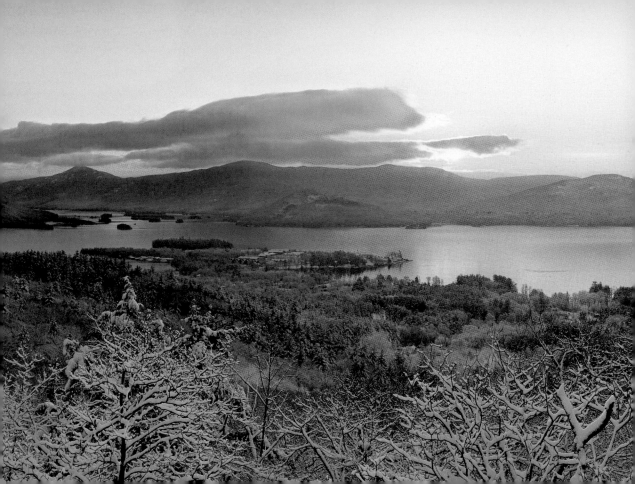

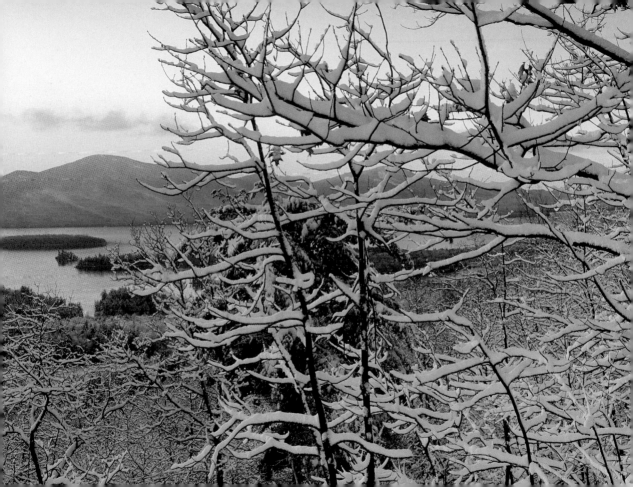

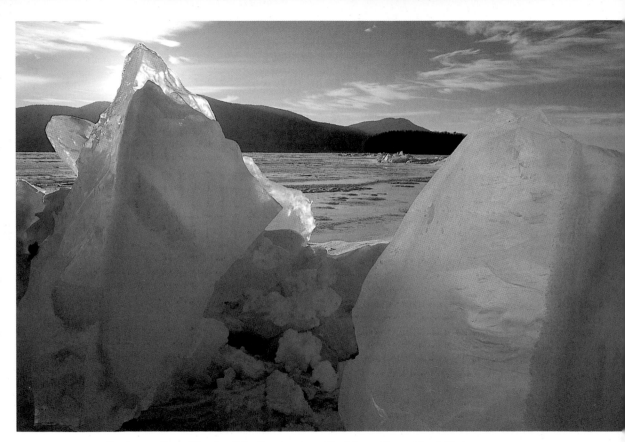

above *Pressure ridge ice near Dome Island on Lake George* opposite *The Schroon River at South Horicon*

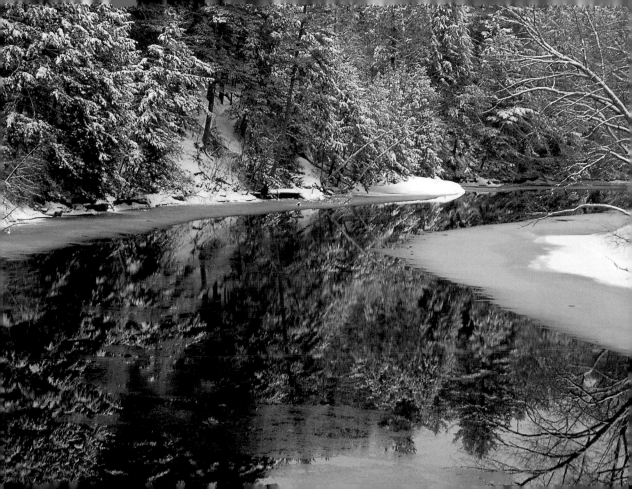

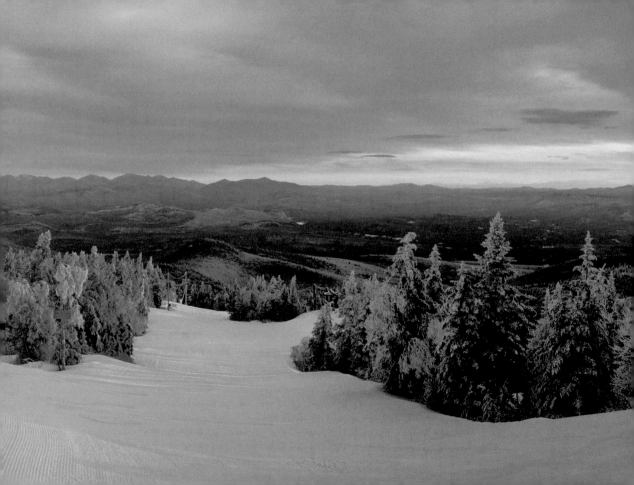

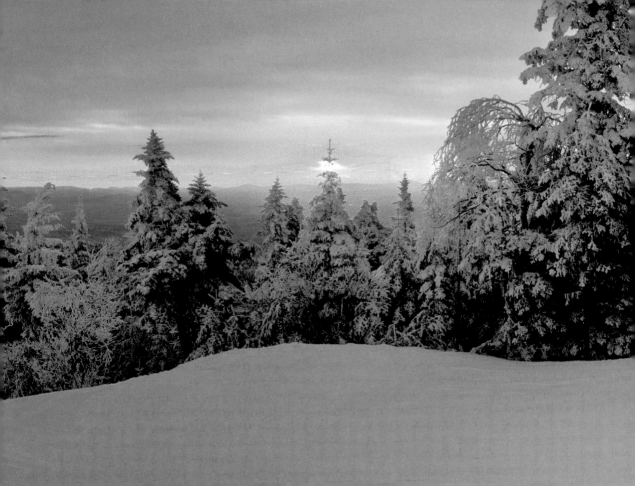

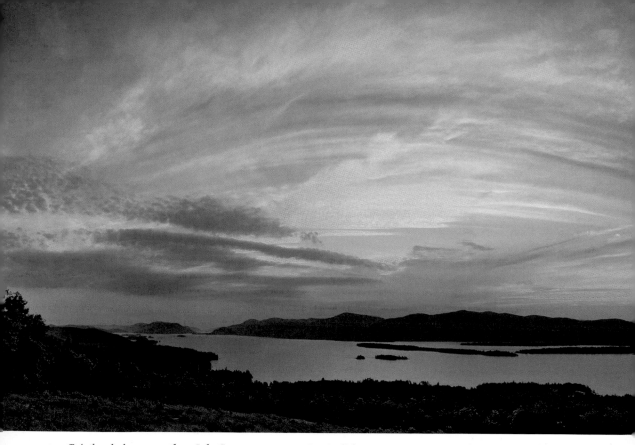

above *Paintbrush sky over southern Lake George* previous page *Sunrise light on Gore Mountain Cloud Trail*

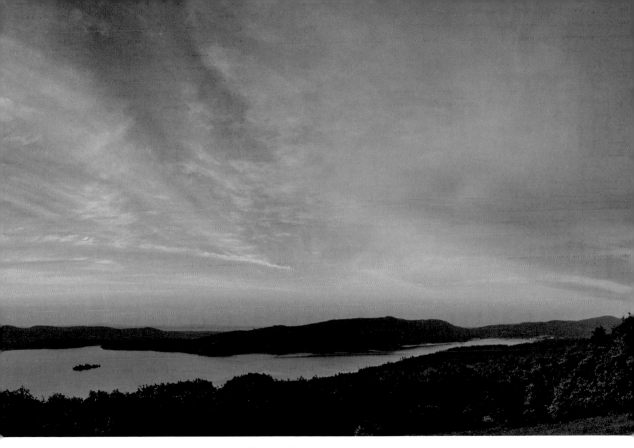

following page *Cat Mountain view of Lake George and Trout Lake*

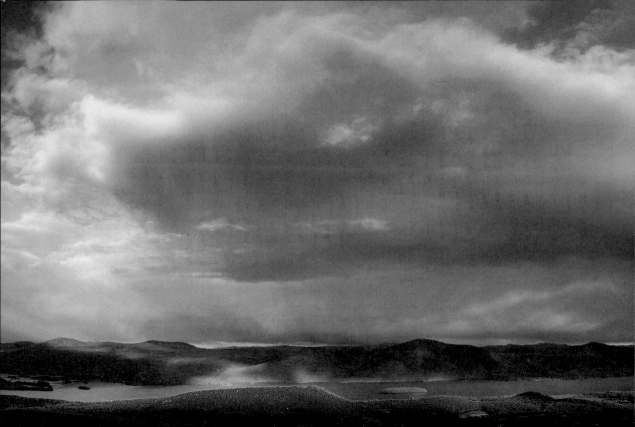

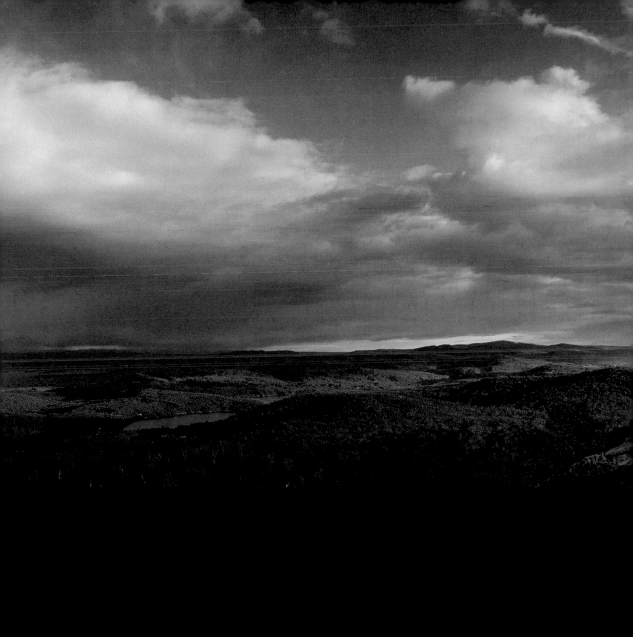

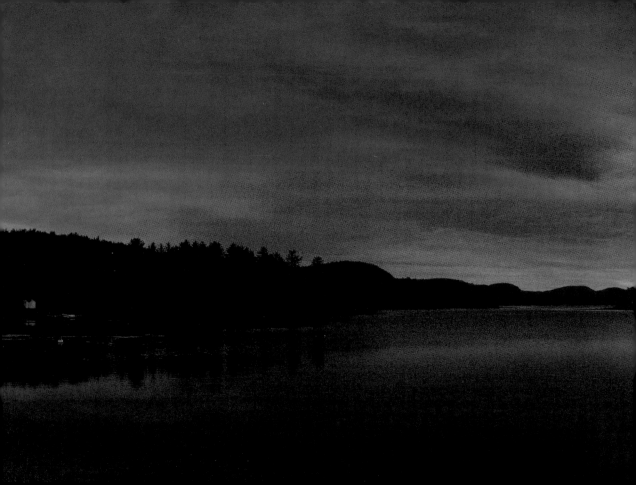

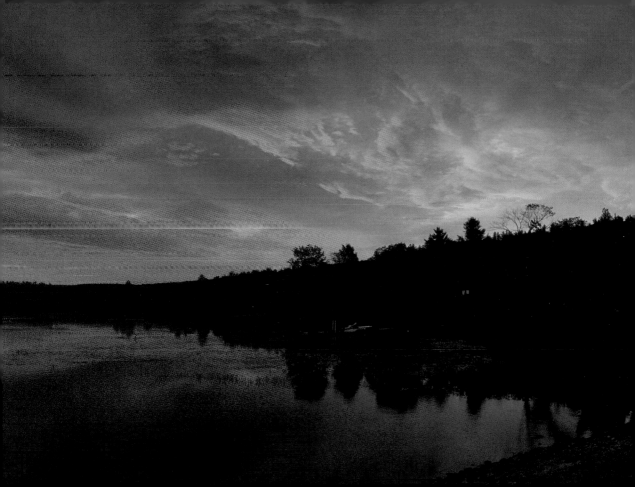

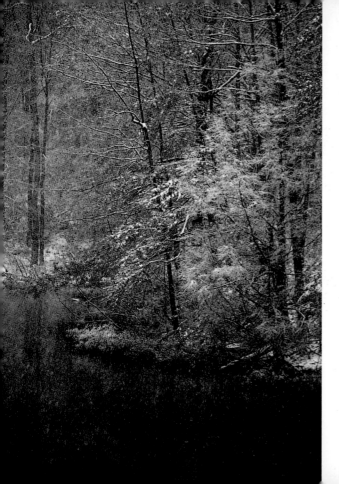

left *First snow at North Pond*
opposite *Aurora borealis over Brant Lake*
previous page *Brant Lake sunrise from the boat launch*
following page *The outlet of Friends Lake*

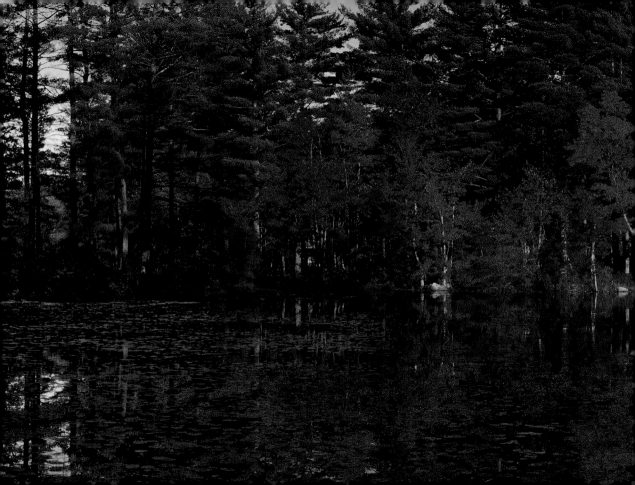

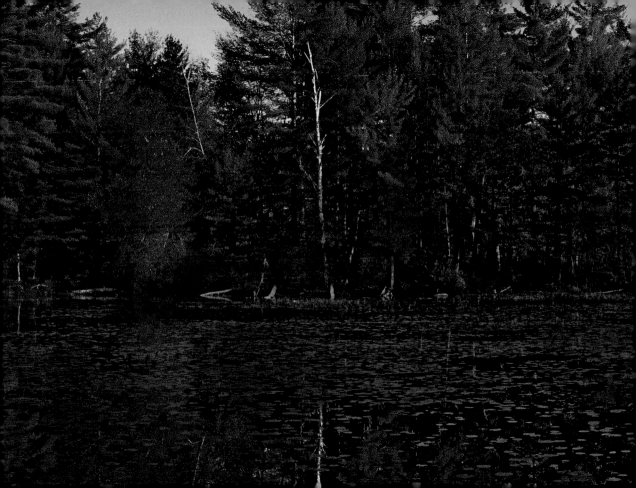

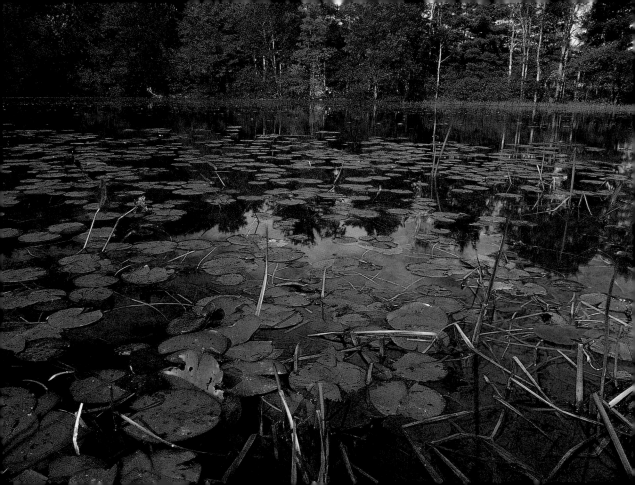

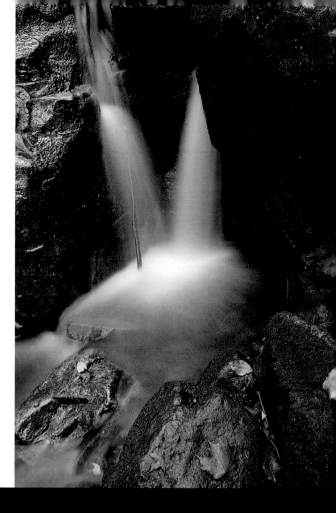

right *Stream near Shelving Rock Mountain, Lake George*
opposite *Along the outlet of Brant Lake*

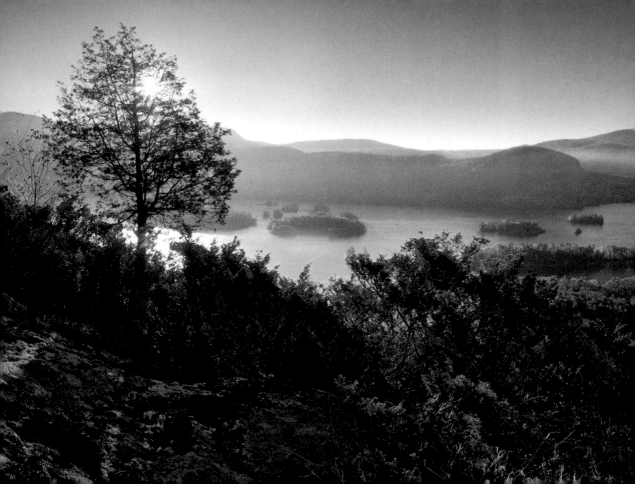

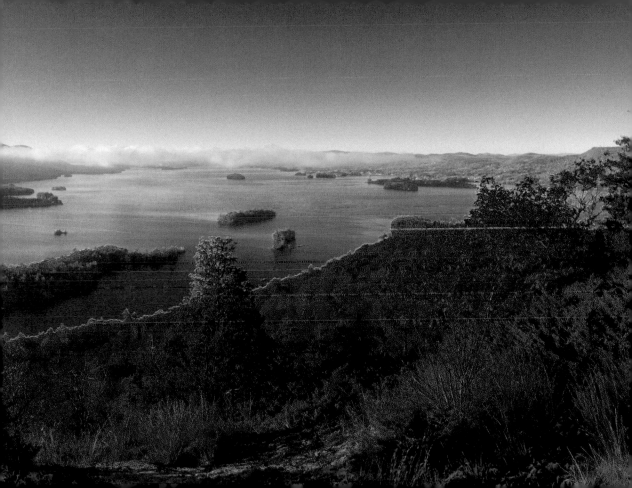

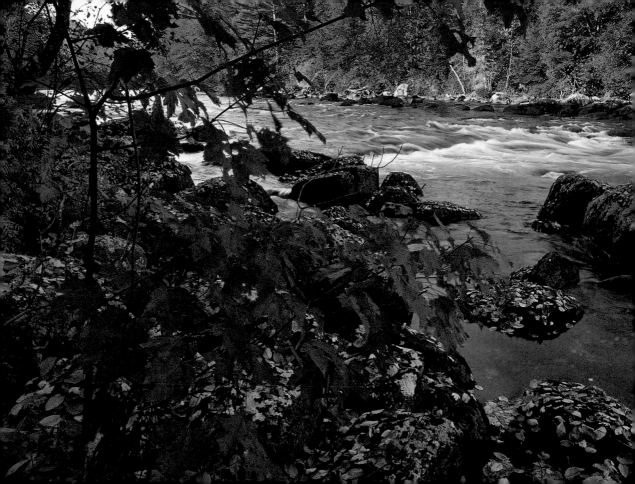

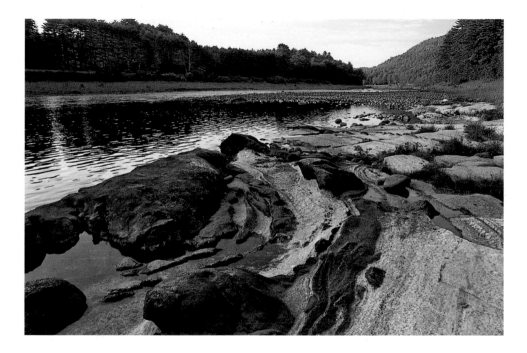

above *Hudson River rock patterns at the Warren County Park* opposite *Fall colors on the Schroon River*
previous page *Lake George from First Peak on the Tongue Mountain Range*

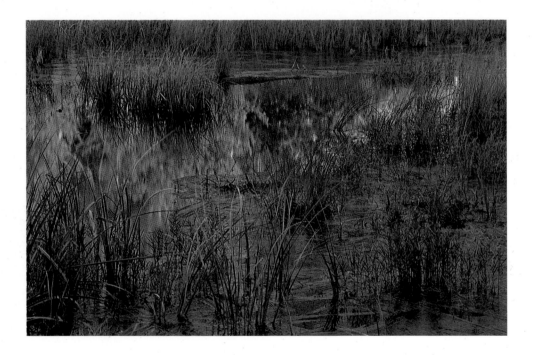

above *Lapland Pond in the Lake George Wild Forest* opposite *Looking north to Pharaoh Mountain*
following page *Hoffman Mountain, the High Peaks, and Schroon Lake*

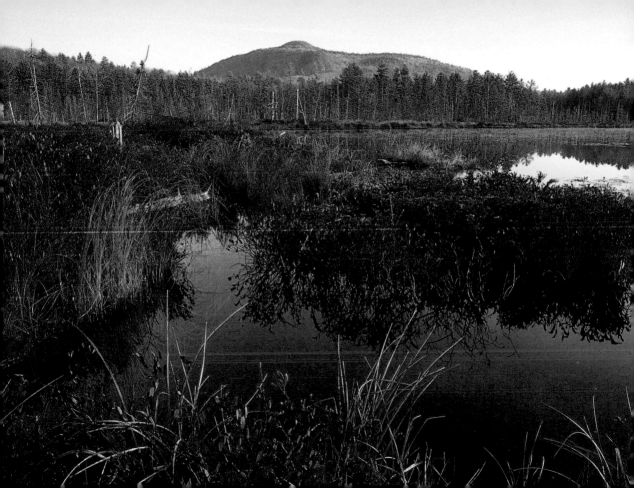

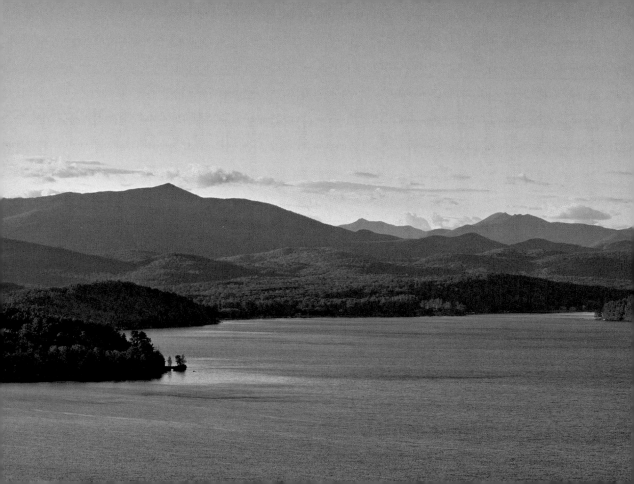

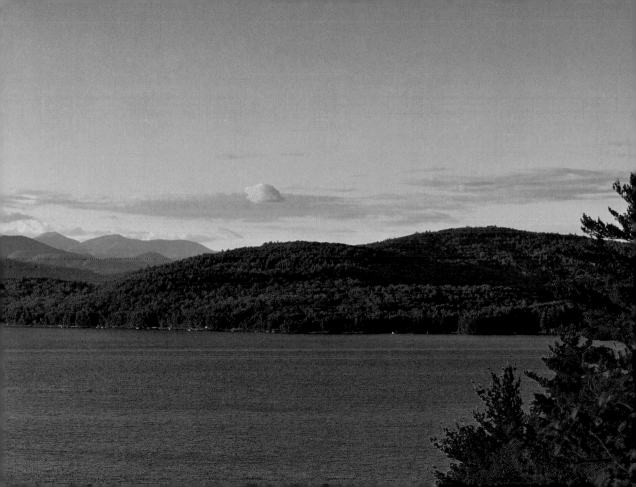

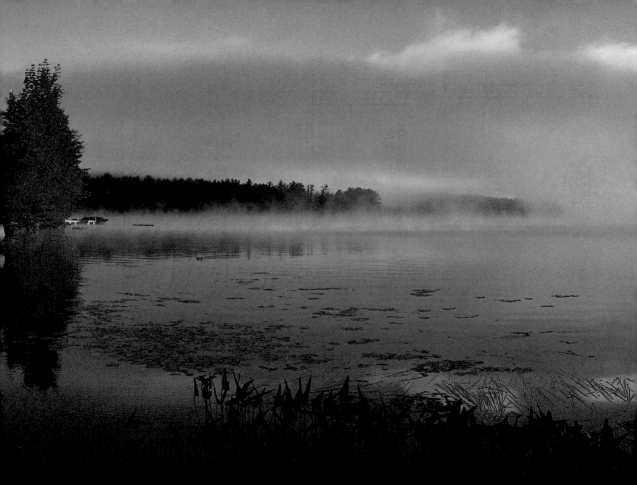

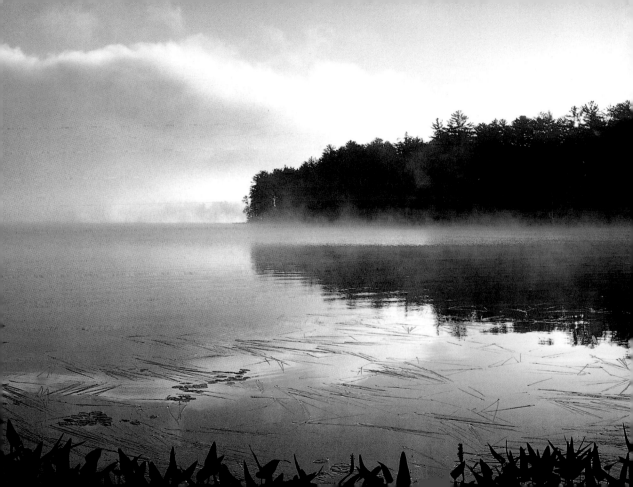

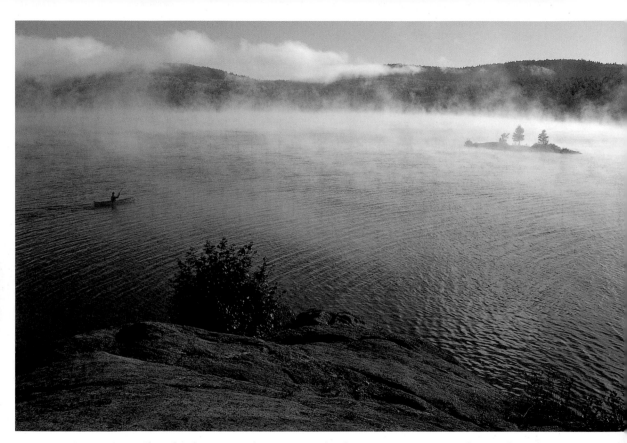

above *Misty morning on Pharaoh Lake* opposite *Lake George near Ticonderoga* previous page *Loon Lake near Chestertown*

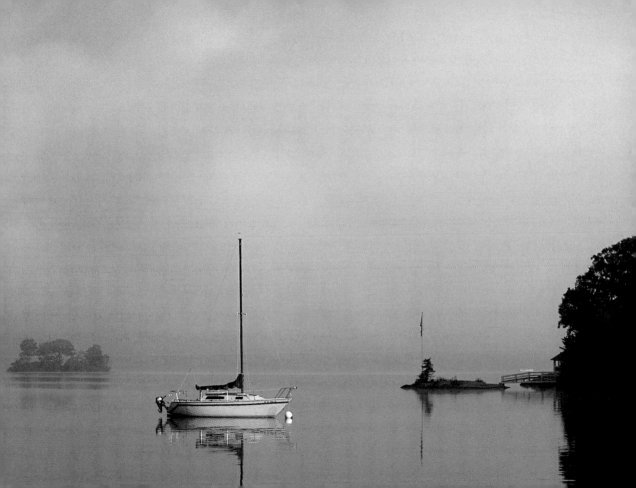

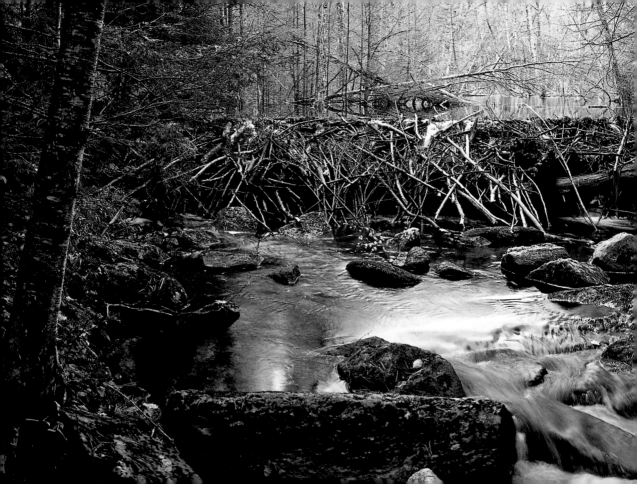

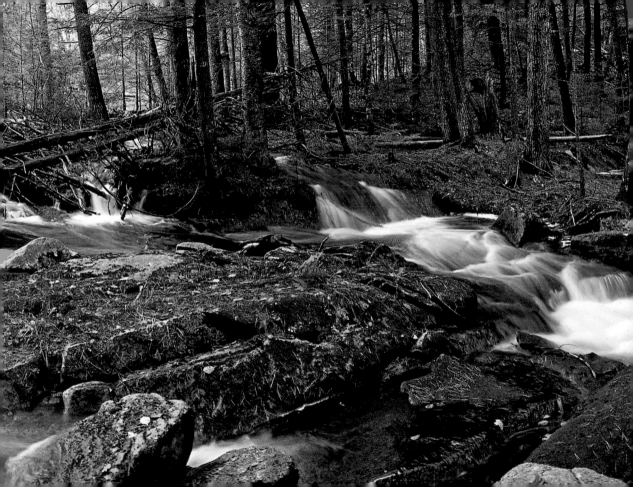

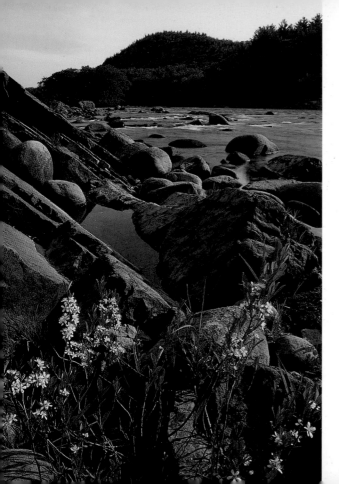

left *Dwarf sand cherry along the Hudson River*
opposite *Natural Stone Bridge and Caves, Pottersville*
previous page *Buttermilk Stream in the Lake George Wild Forest*

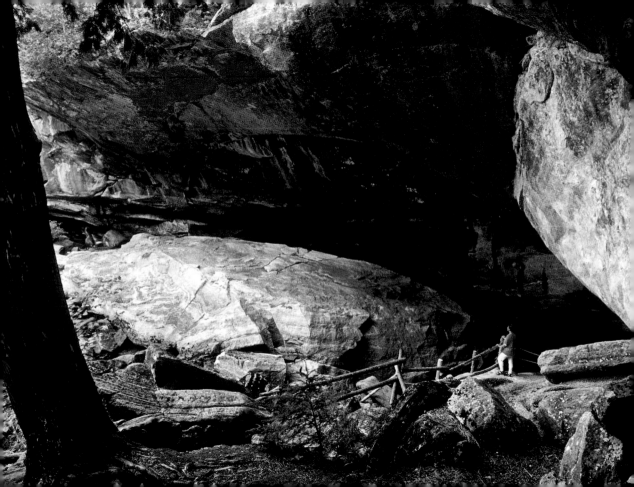

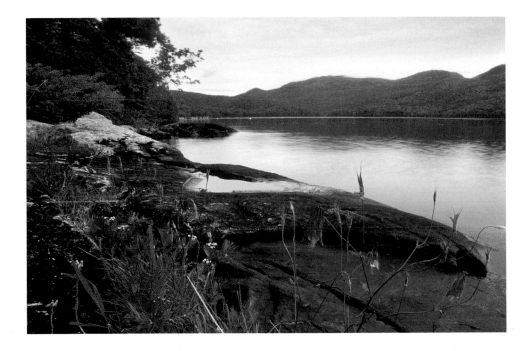

above *Columbine on Northwest Bay of Lake George* opposite *False hellebore leaves in the spring*
following page *Rogers Memorial Park, Bolton Landing, Lake George*

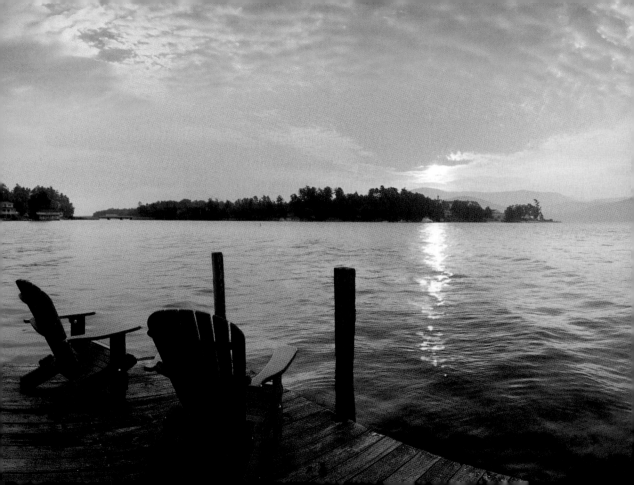

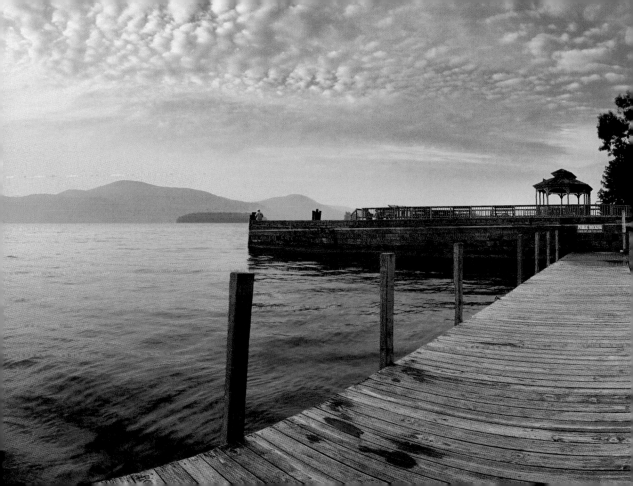

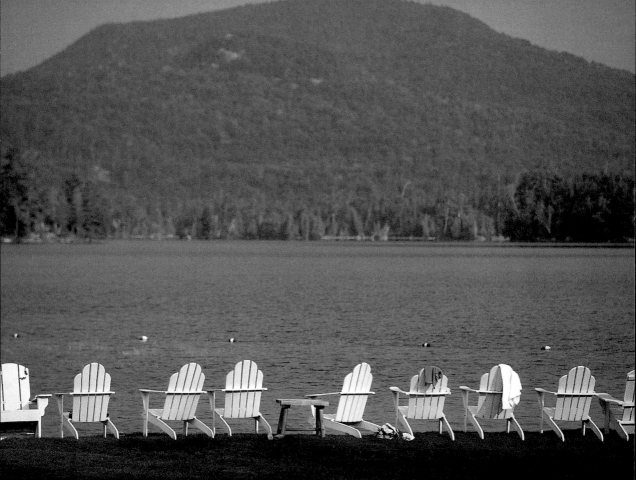

Central and Southern Waterways and Mountains

❧

Blue Mountain Lake, Long Lake, Indian Lake, Lake Durant, Tirrell Pond, Raquette Lake,
Fulton Chain, Old Forge, North Hudson, Siamese Ponds Wilderness,
Snowy Mountain, Sacandaga River, Great Sacandaga Lake,
Wells, Lake Pleasant, Piseco Lake

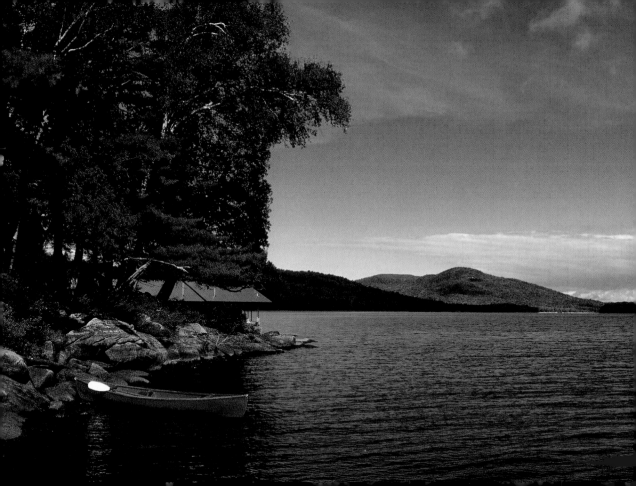

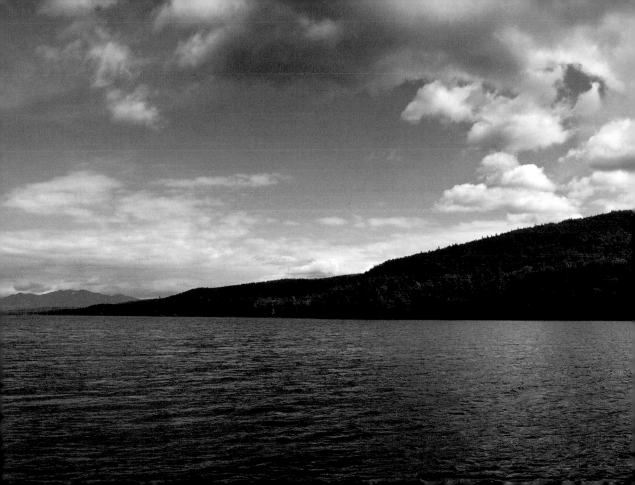

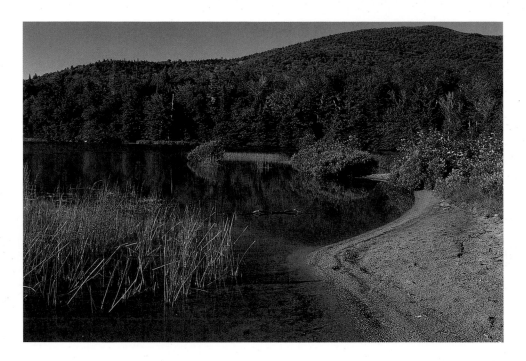

chapter opener *Adirondack chairs at Curry's Cottages on Blue Mountain Lake* previous page *View from Watch Point on Long Lake* above *North shoreline of Tirrell Pond* opposite *Blue Mountain from Blue Mountain Lake* following page *Lake Durant dawn*

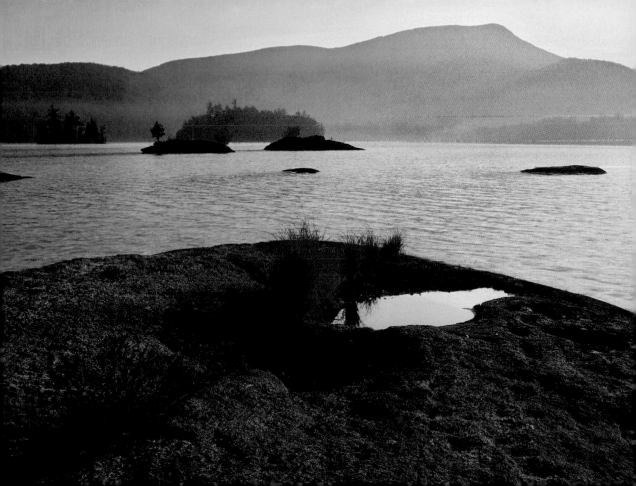

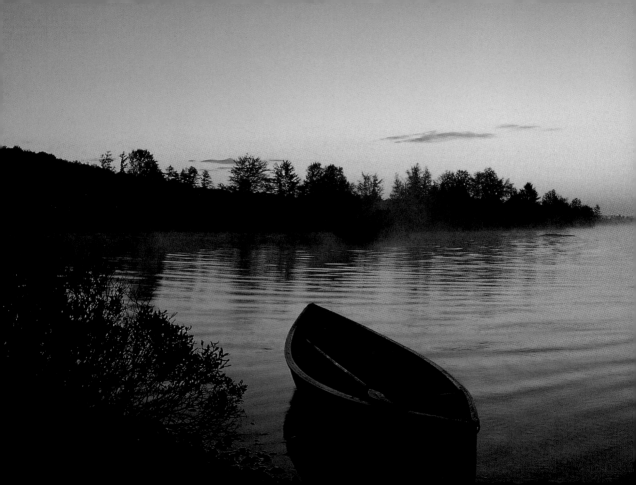

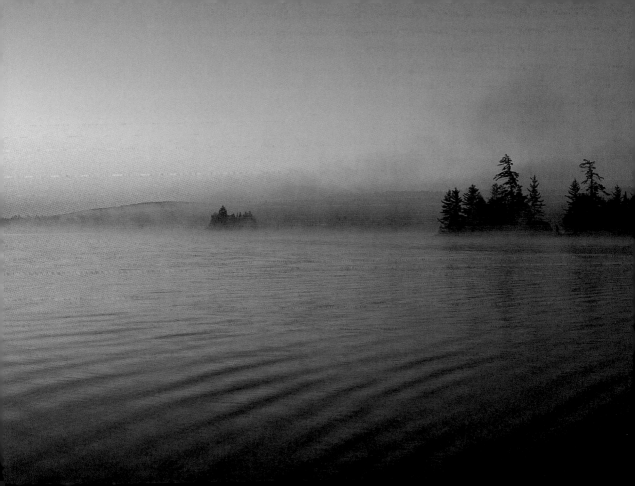

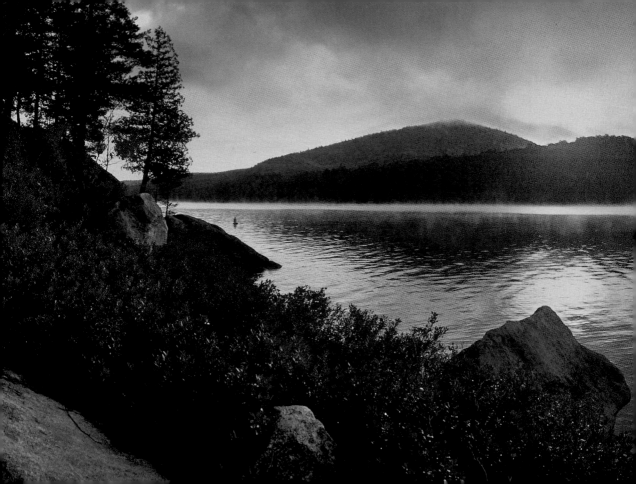

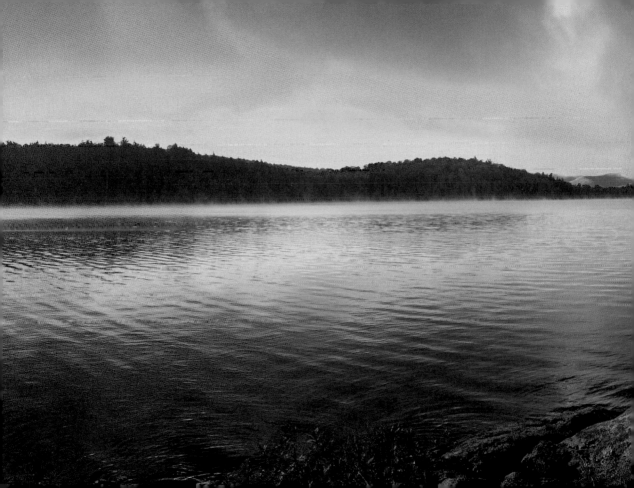

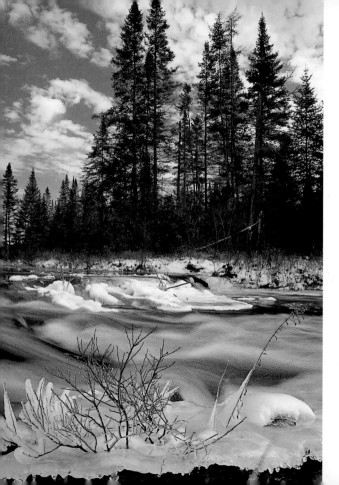

left December ice on the Boreas River
opposite Snow drift on top of Bald Mountain, Old Forge area
previous page Autumn mist over Long Lake

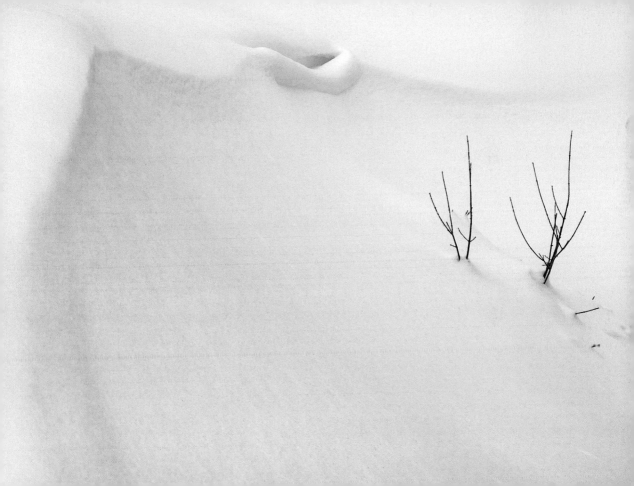

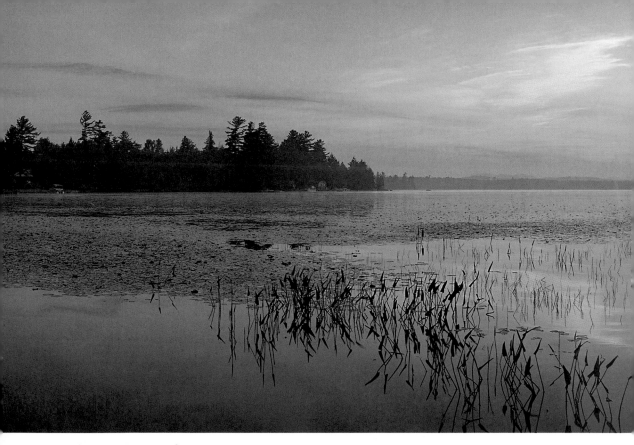

above *Dawn over Raquette Lake*

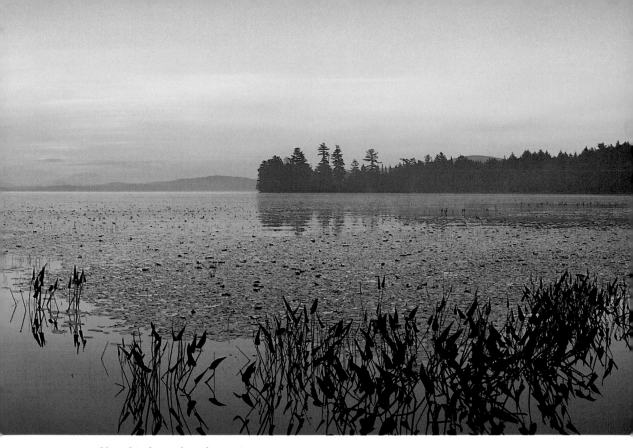

following page *A wild pond in the North Hudson region*

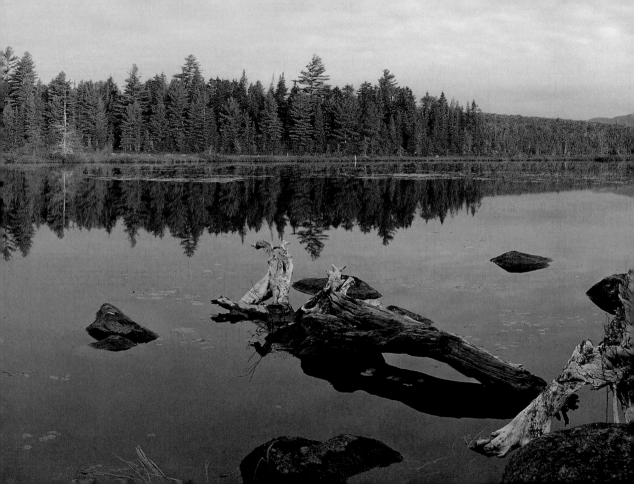

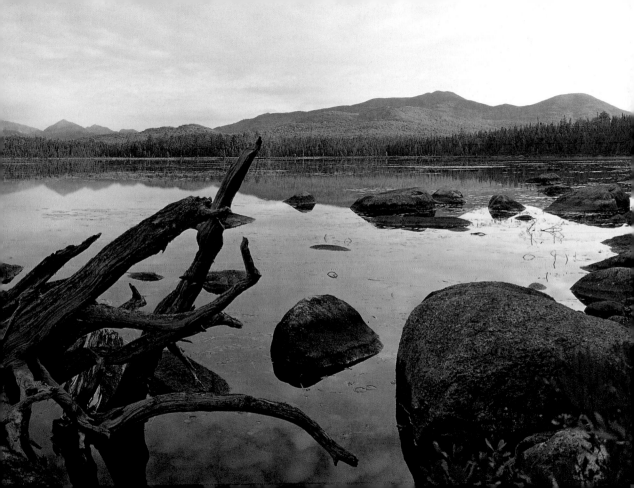

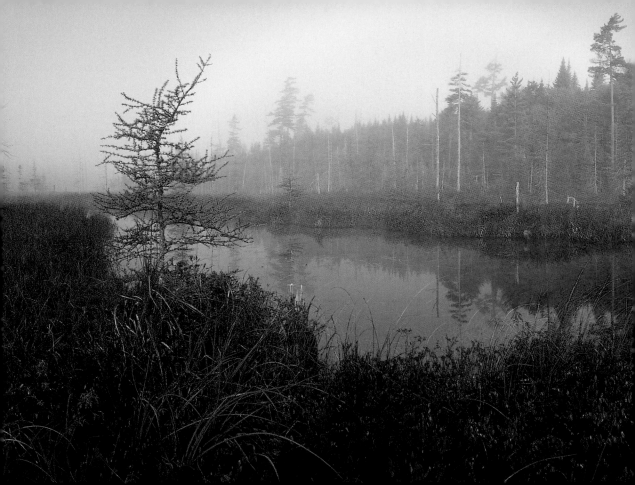

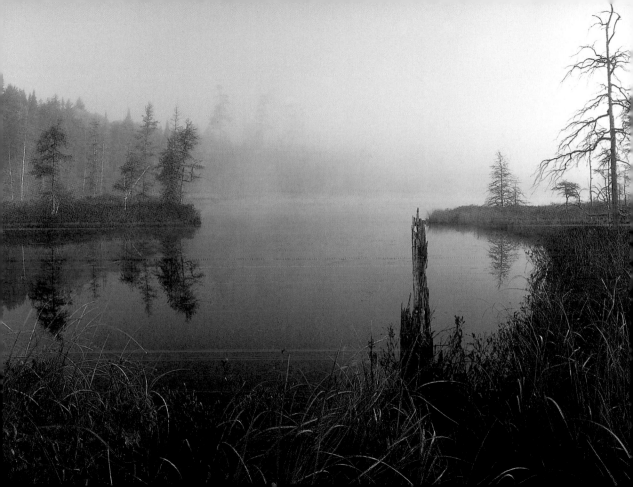

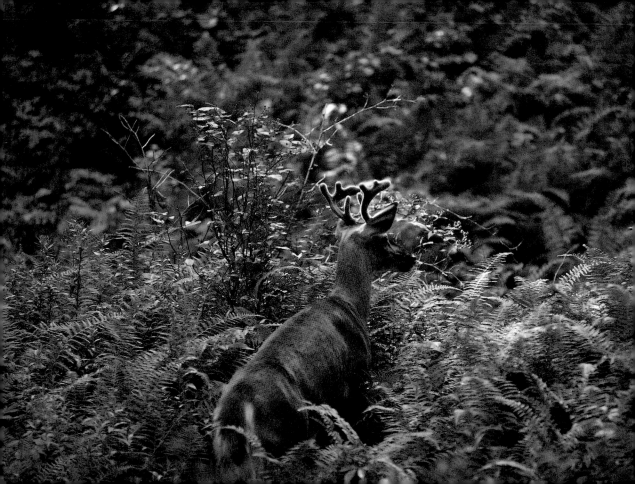

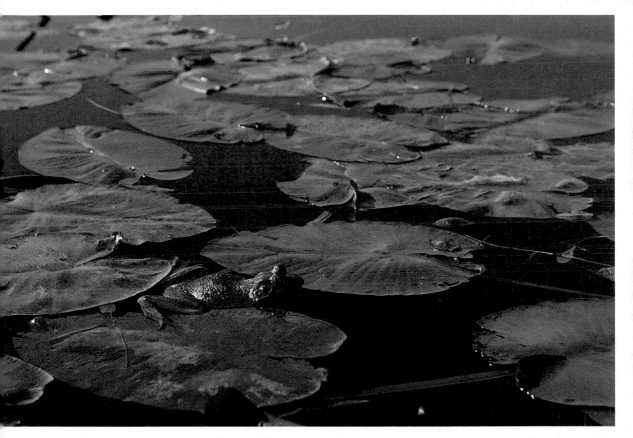

above **North Hudson area** opposite *Buck in velvet near Blue Mountain Lake* previous page *Wetland at Ferd's Bog near Inlet*

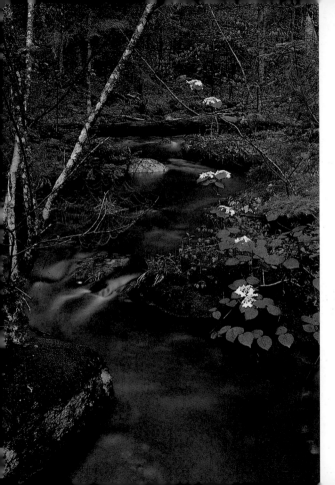

left *Stream along the trail to Vanderwhacker Mountain*
opposite *Rose pogonia blooming along Grassy Pond in the Blue Ridge Wilderness*
following page *Lake Abenakee near Indian Lake*

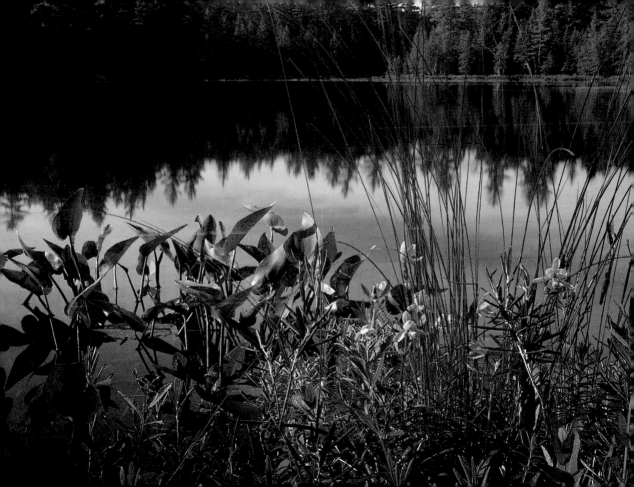

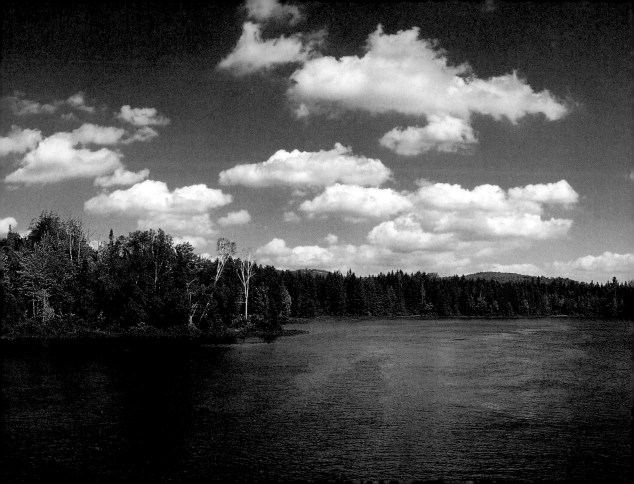

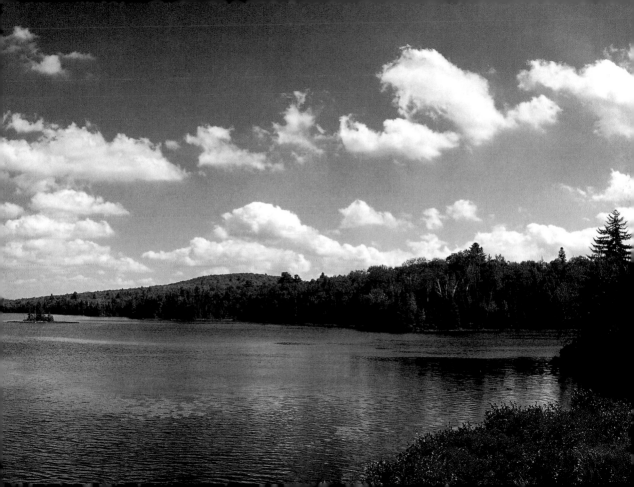

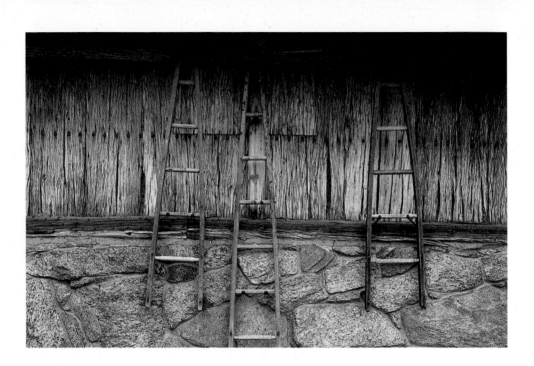

above *Great Camp Sagamore detail, Raquette Lake*
opposite *Doors of the historic main lodge at Great Camp Sagamore*

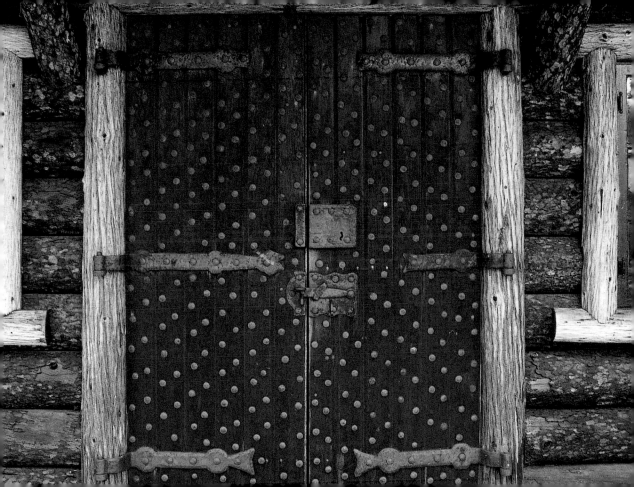

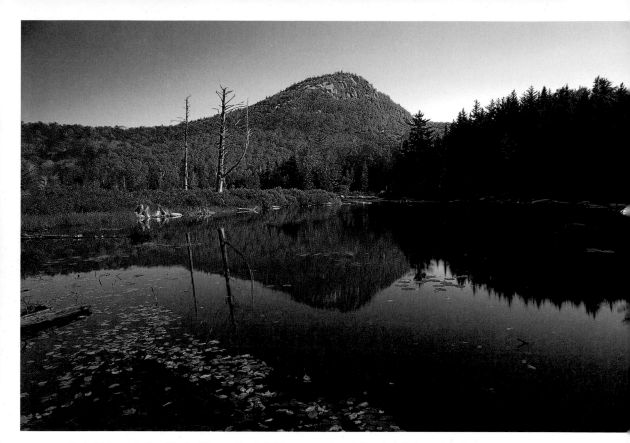

above *Peaked Mountain Pond in the Siamese Ponds Wilderness* opposite *Adirondack light on Lake Durant*

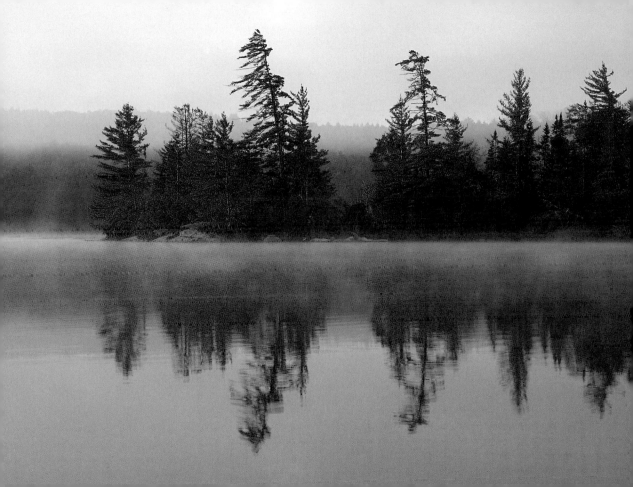

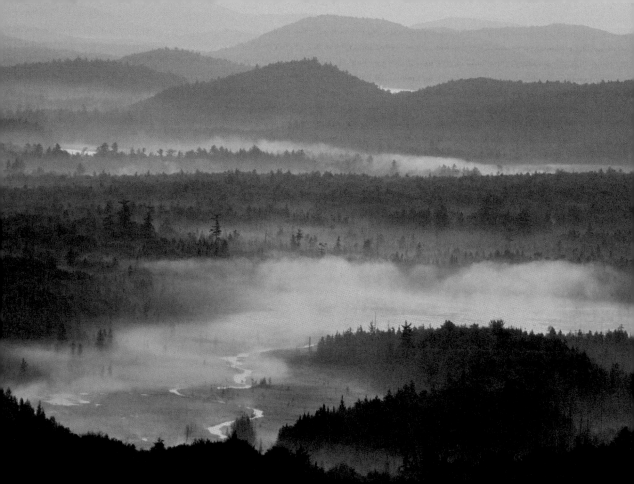

right *Snowy from Peaked Mountain*
opposite *Twilight detail in the Pigeon Lake Wilderness from Black Bear Mountain*
following page *Sunset light on storm clouds at Lake Durant*

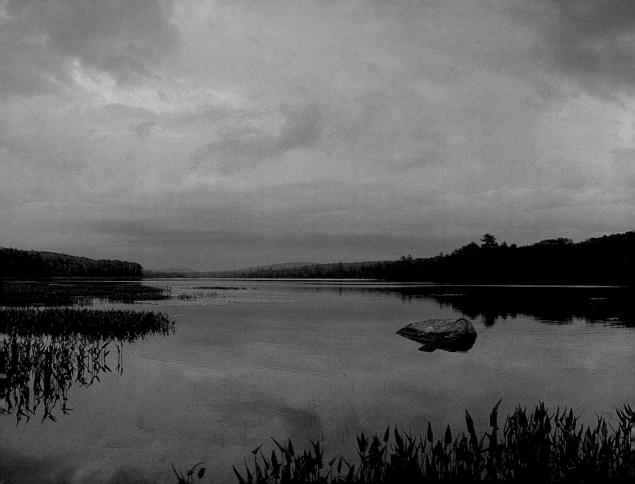

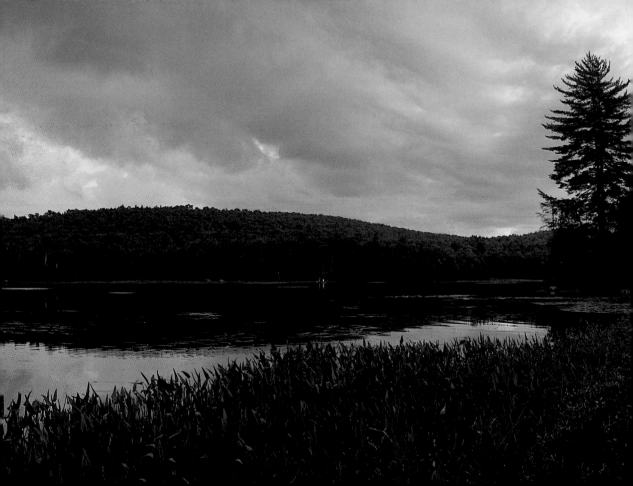

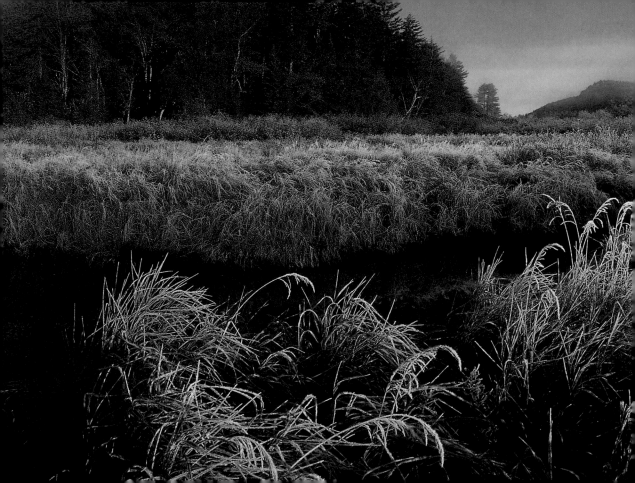

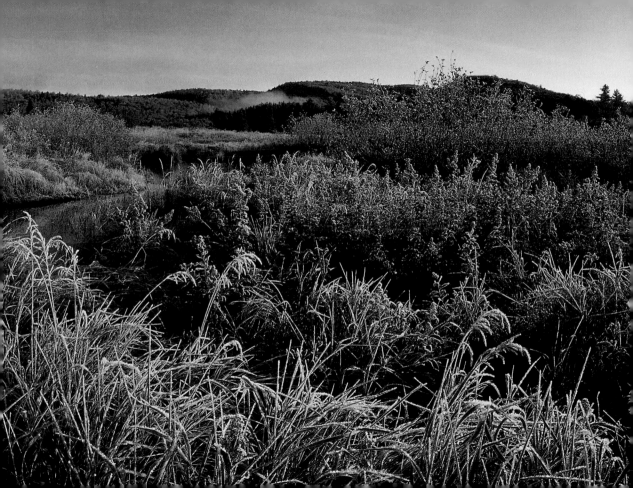

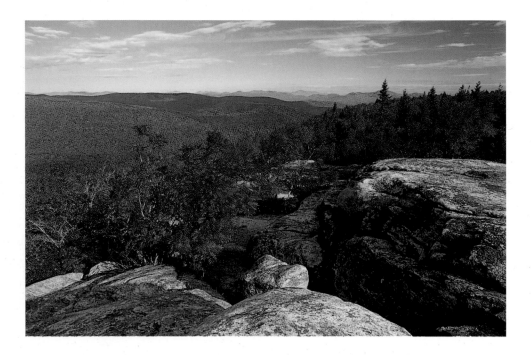

above *Looking north from Hadley Mountain* opposite *Hornbeck canoe on the outflow of Good Luck Lake*
previous page *Morning along a tributary to the West Branch of the Sacandaga River*
following page *Sunrise over the Inlet and Old Forge area from Bald Mountain*

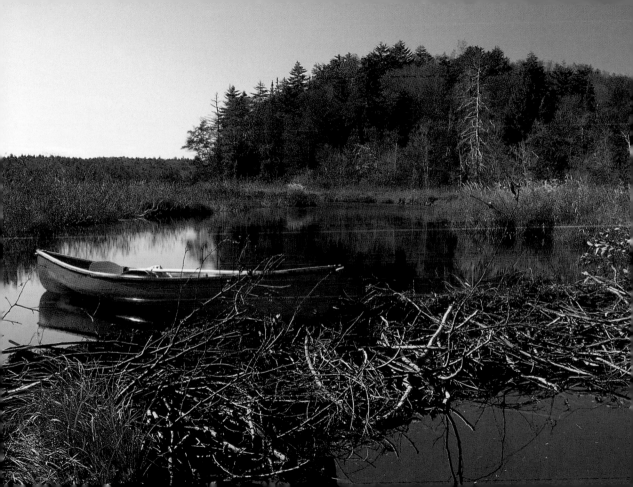

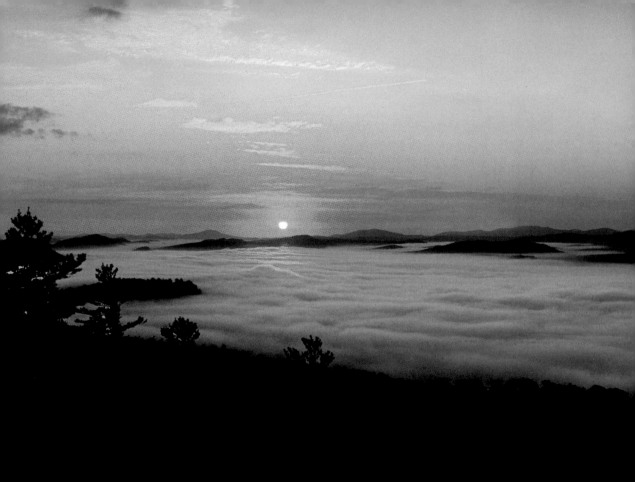

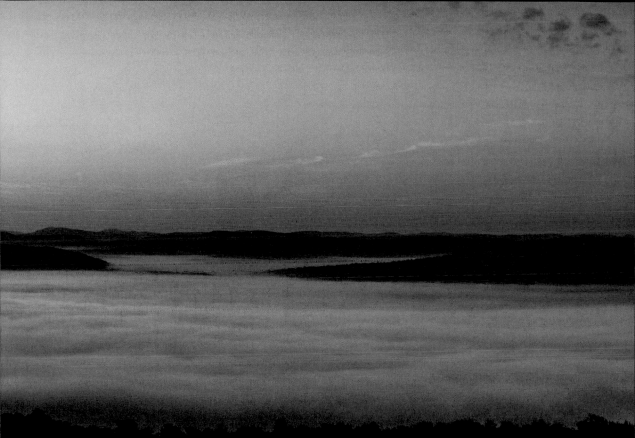

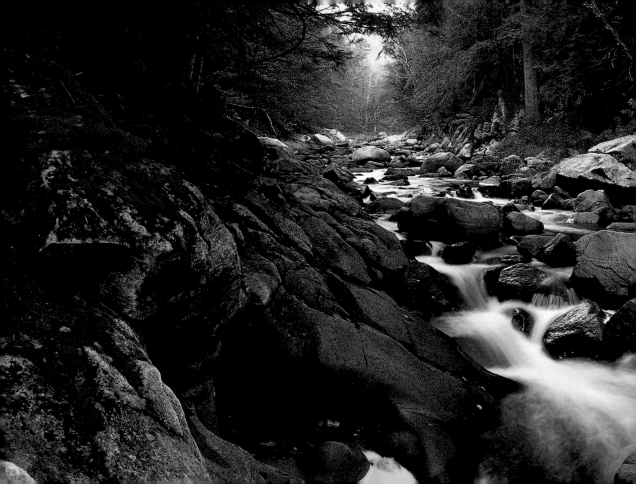

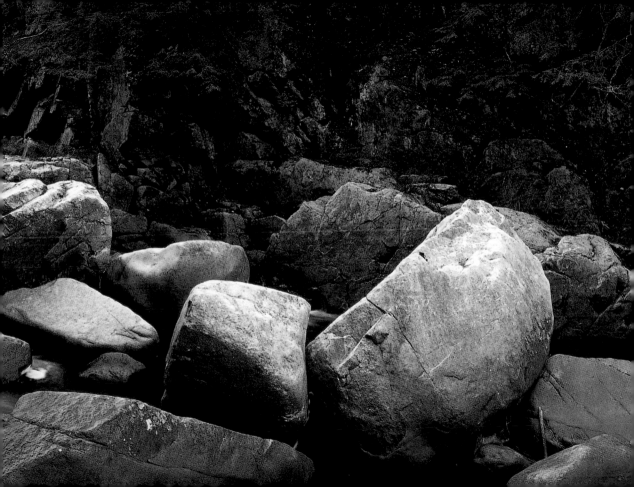

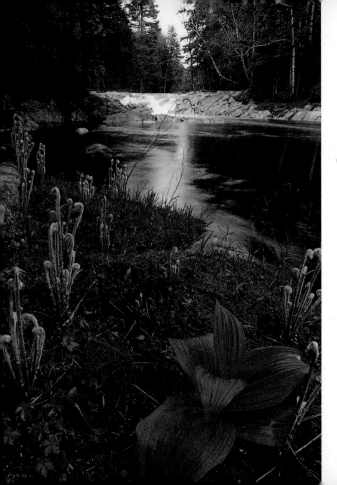

left Fiddleheads and false hellebore along the East Branch of the Sacandaga River

opposite Silver maples line the bank of the Sacandaga River at Auger Flats

previous page East Branch of the Sacandaga River in the southern Siamese Ponds Wilderness

following page Spring showers pass over Buck Bay just east of Speculator

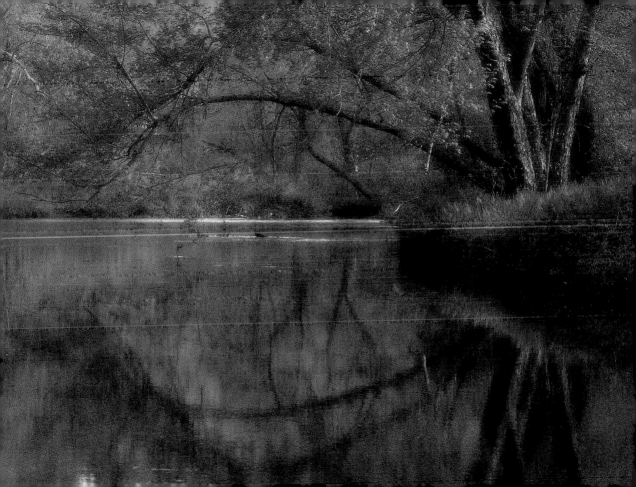

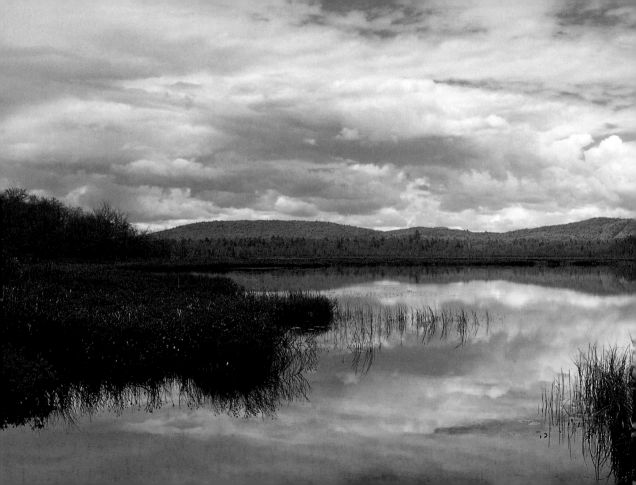

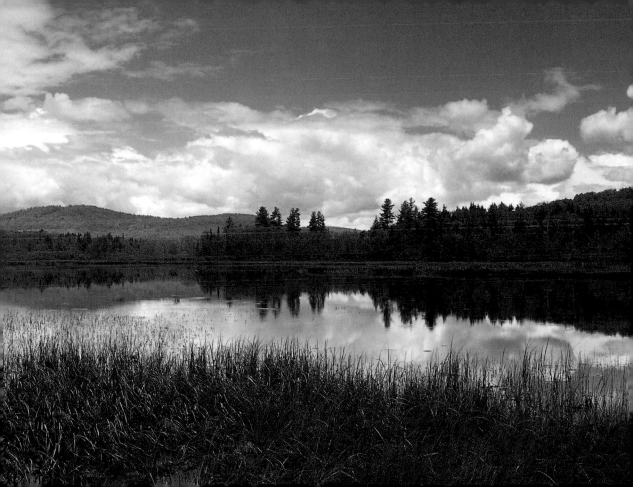

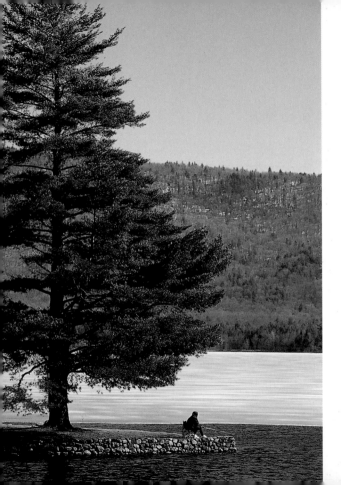

left *Fishing on a sunny spring day on Lake Pleasant*
opposite *The outlet of Sacandaga Lake*
following page *Lake Algonquin in Wells*

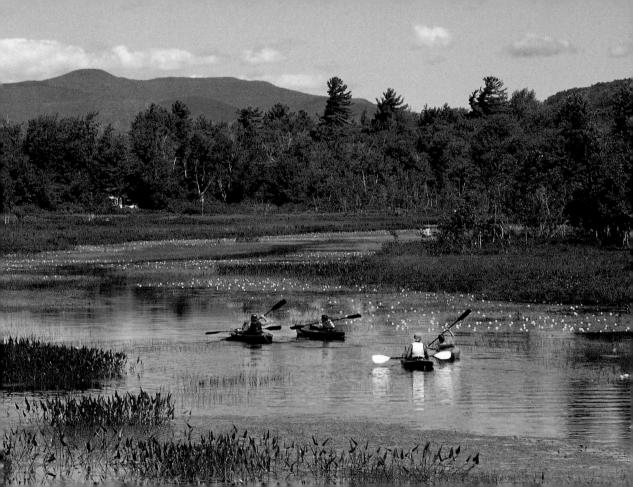

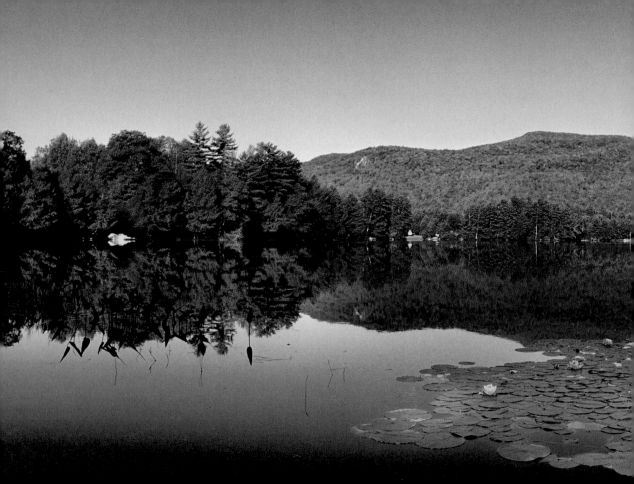

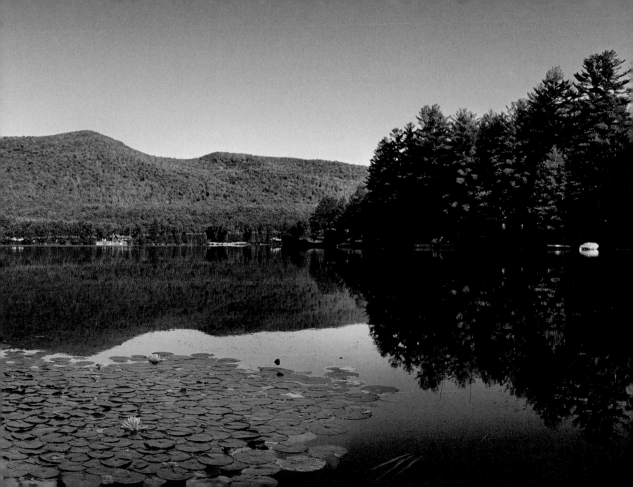

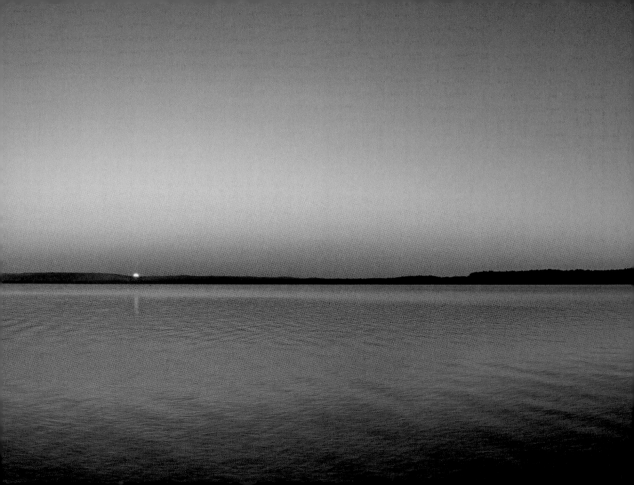

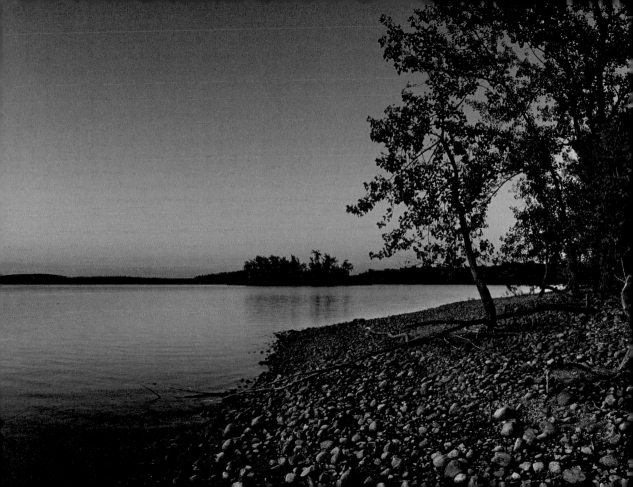

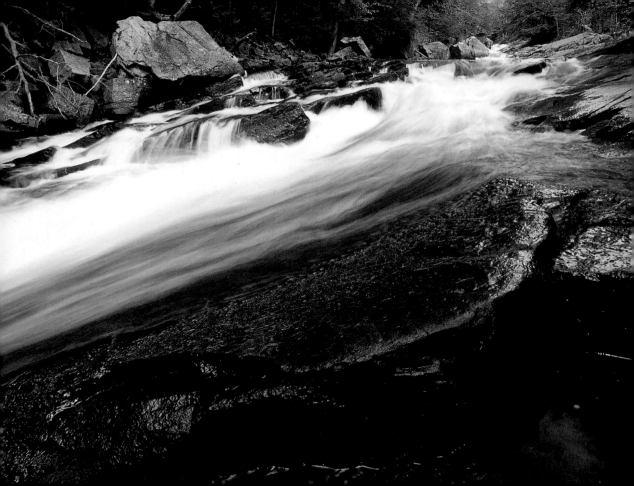

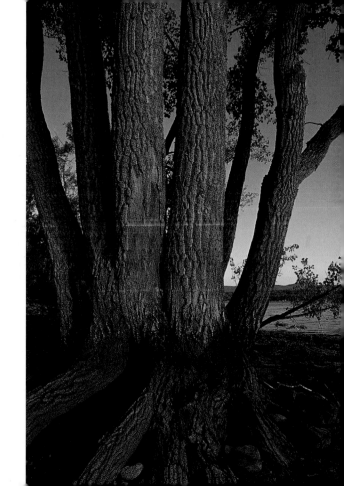

right A Cottonwood tree along the shore of Great Sacandaga Lake
opposite Austin Falls on the Sacandaga River
previous page Sunrise over the Great Sacandaga Lake from Vandenburgh Point
following page Evening twilight at Poplar Point State Campground on Piseco Lake

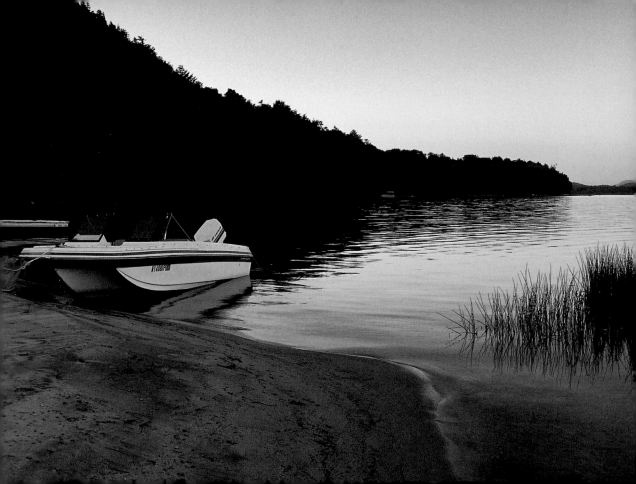

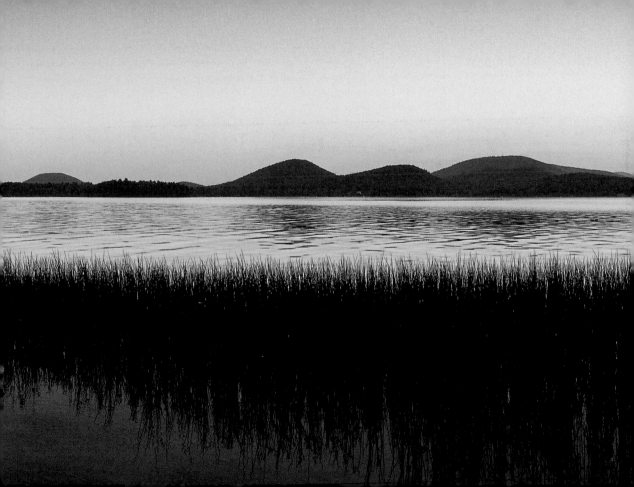

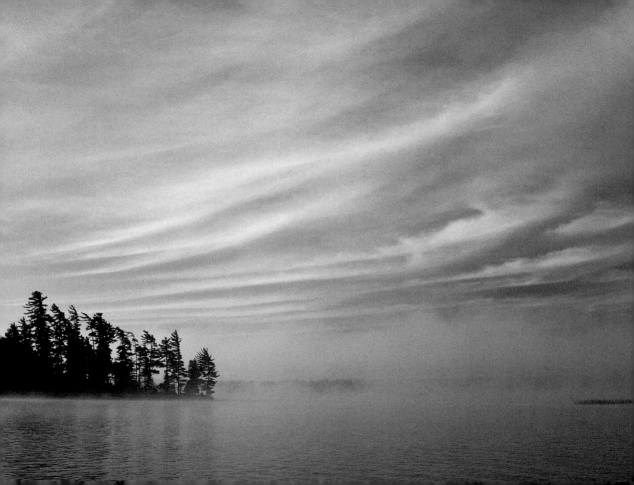

The Boreal North

Lake Lila, Little Tupper Lake, Cranberry Lake, Five Ponds Wilderness, Oswegatchie River, Grasse River, Bog River, Raquette River, Tupper Lake, Mount Arab, Paul Smiths, Osgood Pond, Saint Regis Canoe Area, the Saranacs, Lyon Mountain, Chazy Lake, Poke-O-Moonshine

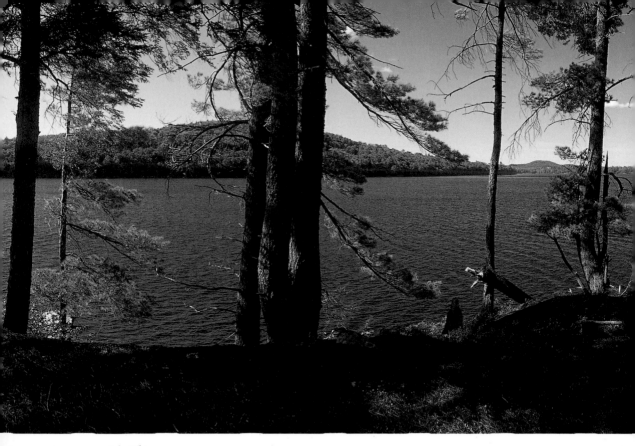

chapter opener *Lake Lila*

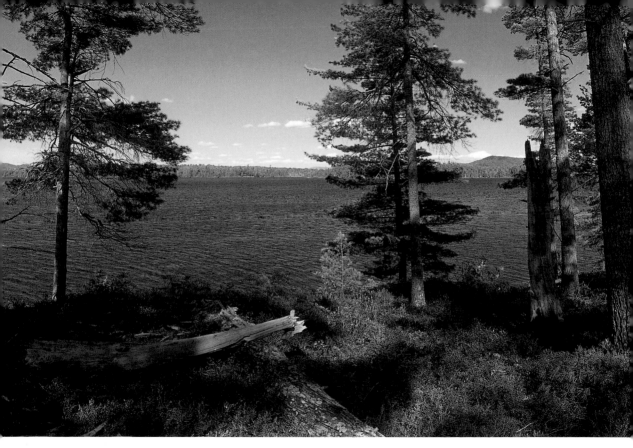

above *Wild shoreline of Round Lake near Little Tupper Lake*

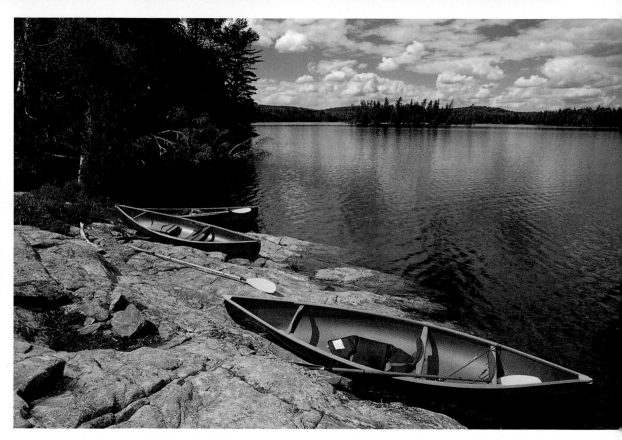

above *Hornbeck canoes on the shore of Little Tupper Lake* opposite *A peaceful sandy inlet on Round Lake* following page *Round Lake*

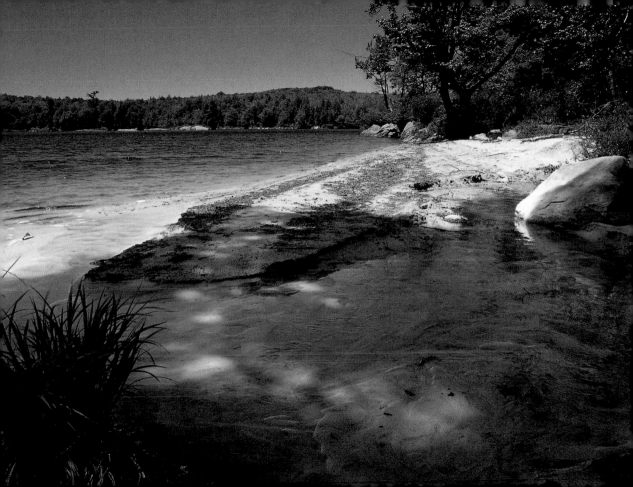

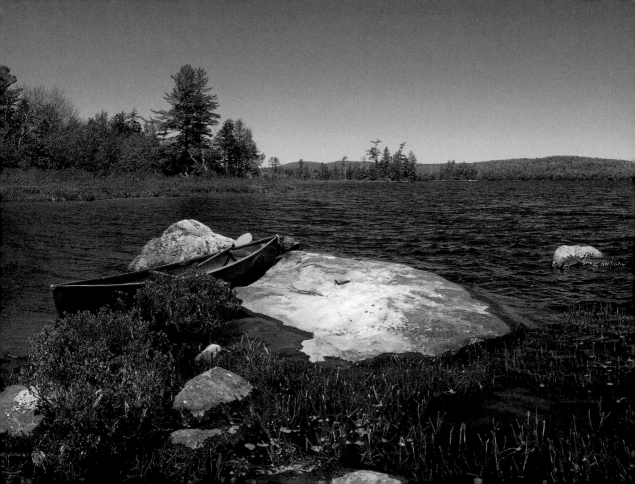

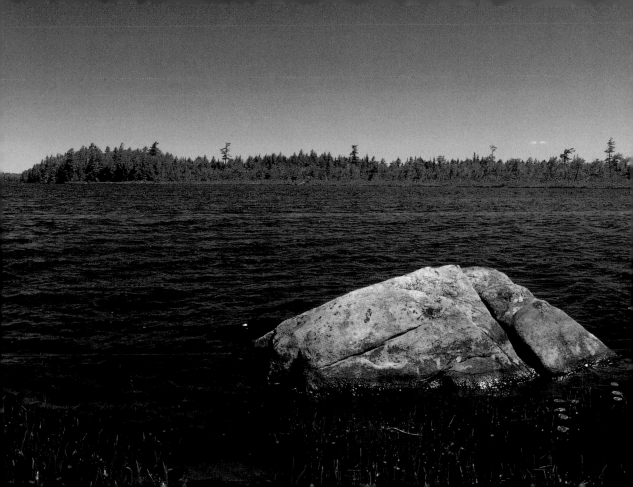

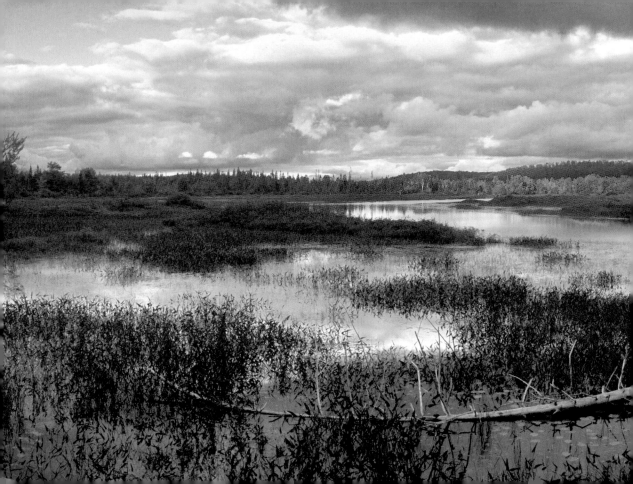

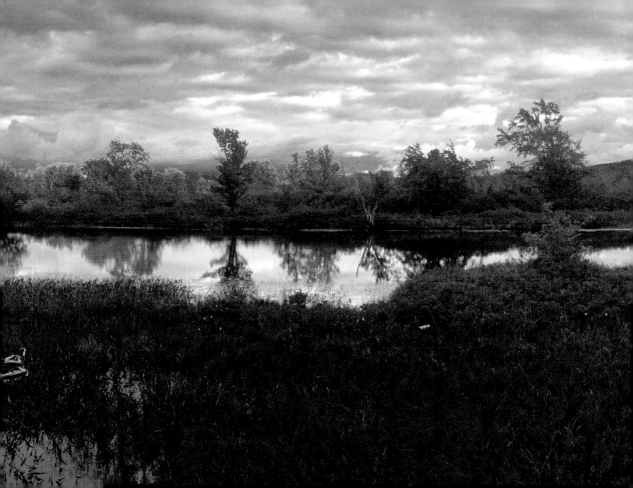

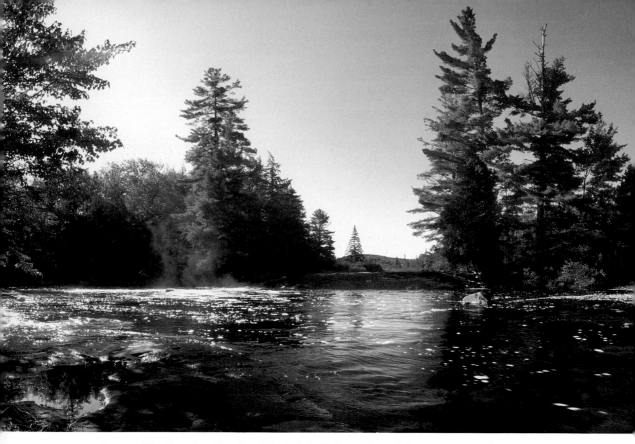

previous page *Raquette River from the observation deck of The Wild Center, Tupper Lake*

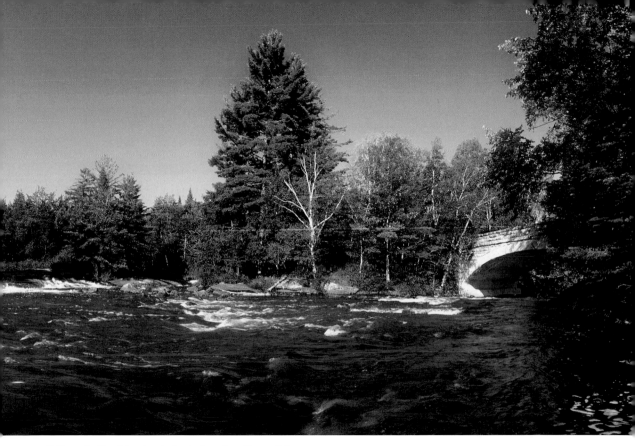

above *Falls on the Bog River just before it flows into Tupper Lake*

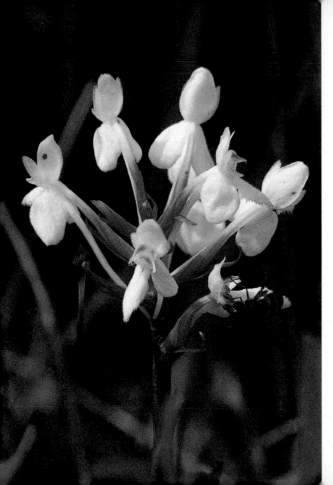

left *Showy orchis blossoms in Spring Pond Bog*
opposite *A tributary stream to Sand Lake in the Five Ponds Wilderness* following page *The teaching bog at the Adirondack Nature Conservancy's Spring Pond Bog Preserve*

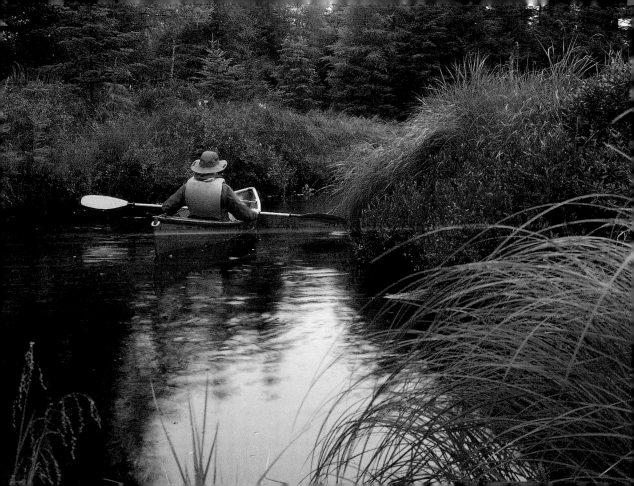

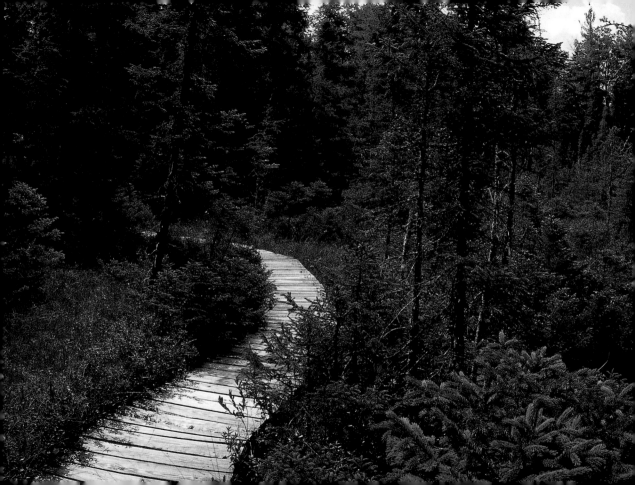

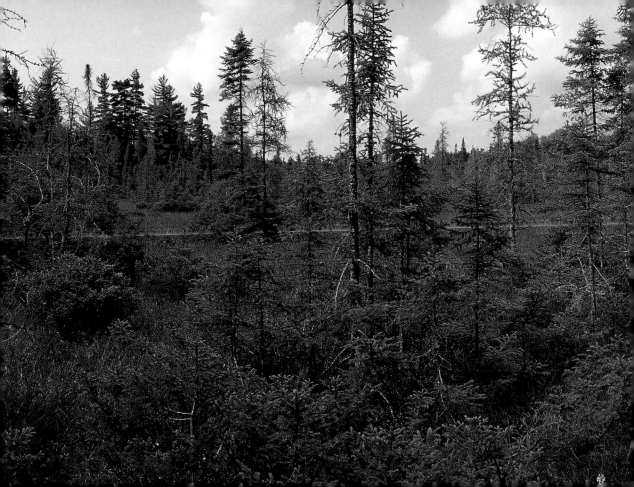

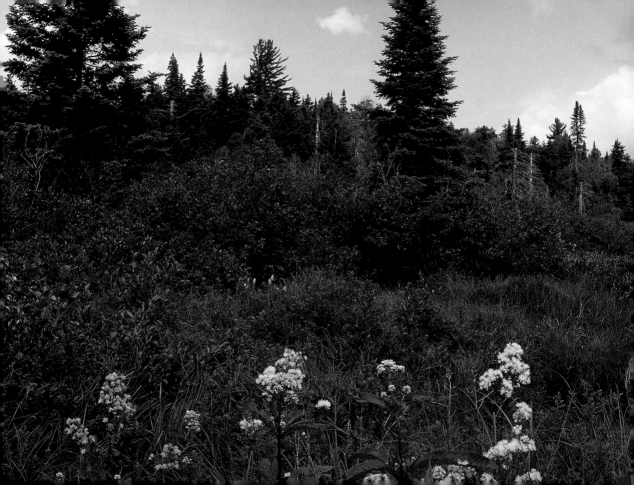

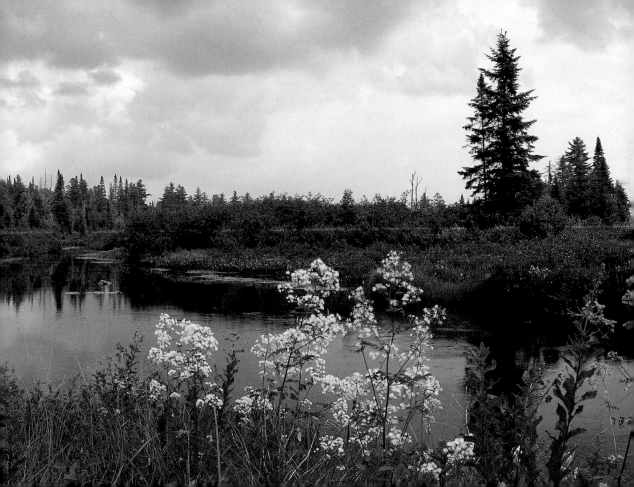

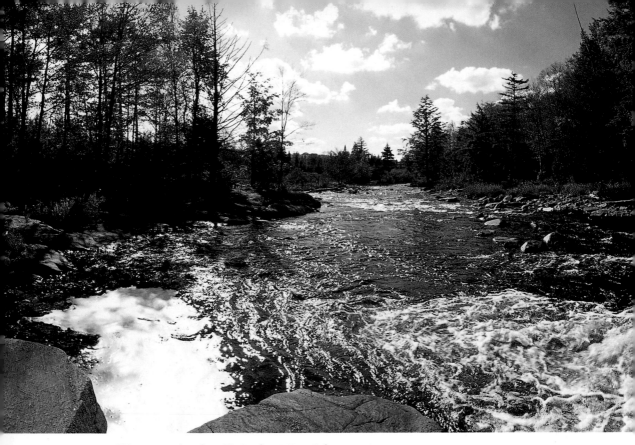

previous page *Wildflowers growing along Big Brook near Long Lake*

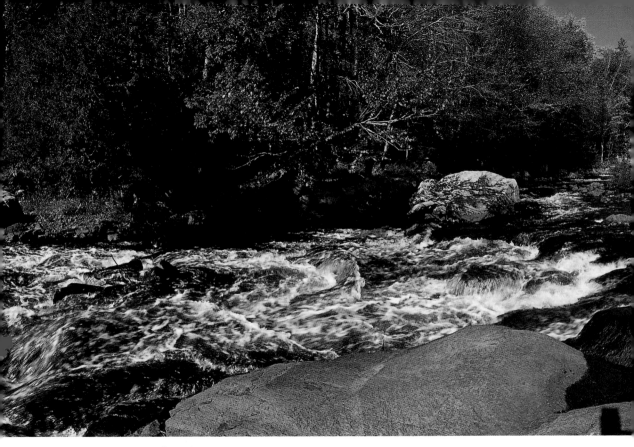

above *The base of Copper Rock Falls on the Grasse River*

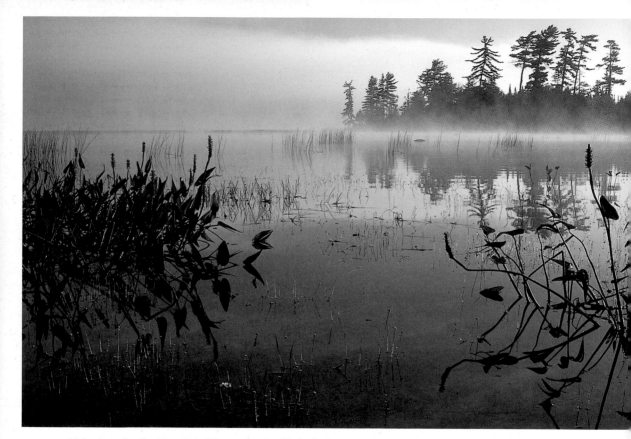

above *Pickerel weed and mist on Lake Lila* opposite *Sand Lake Outlet*

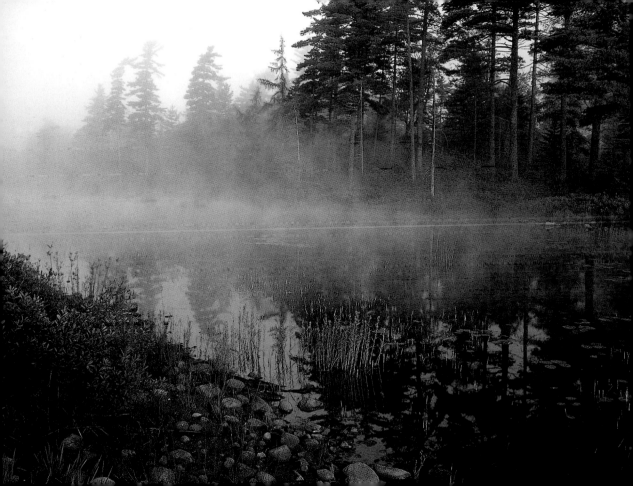

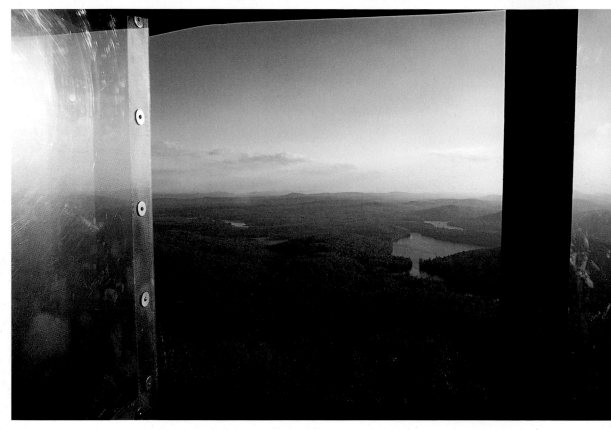

above *Looking toward Tupper Lake from the Mount Arab fire tower* opposite *Morning light silhouettes the Lake Lila shoreline*

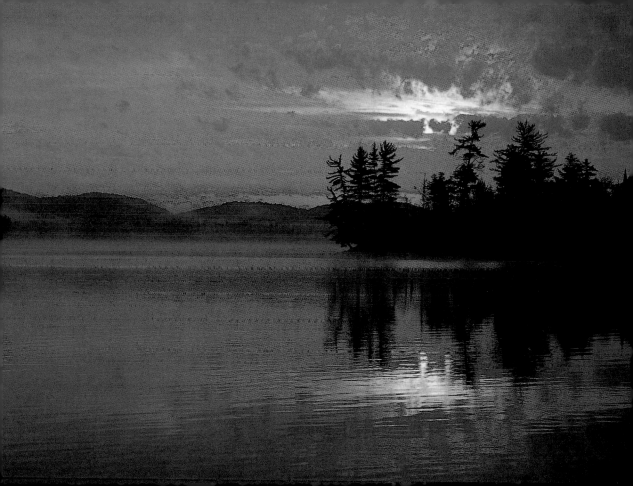

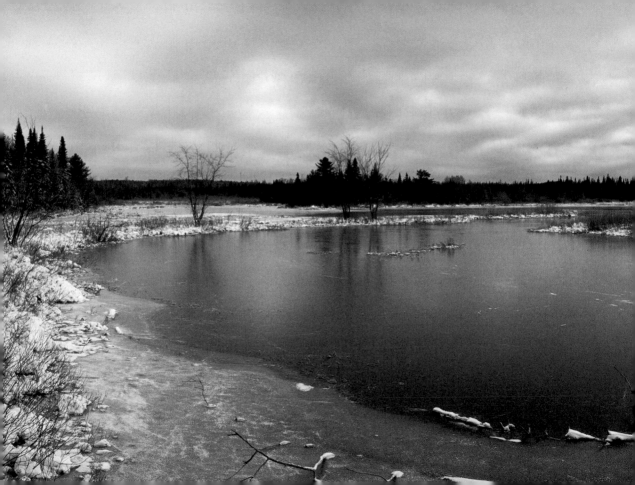

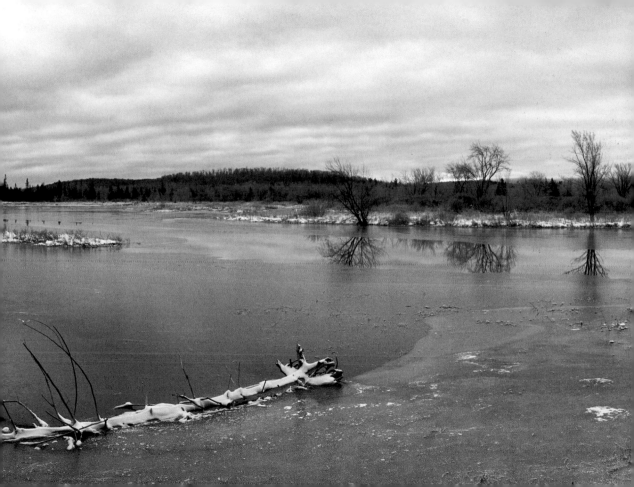

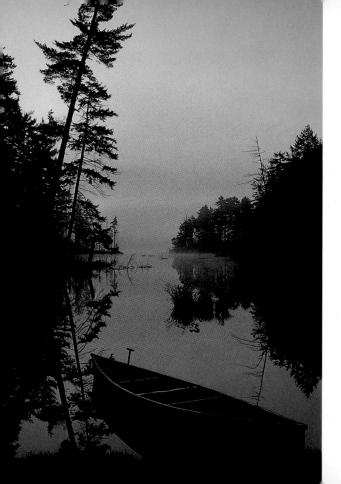

left *Dawn in the Saint Regis Canoe Area*
opposite *Detail in the mist at Saint Regis Pond*
previous page *Early winter view of the Raquette River Oxbow at The Wild Center*

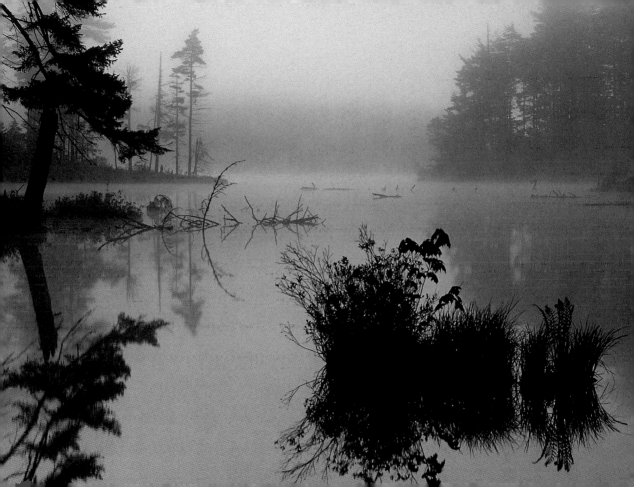

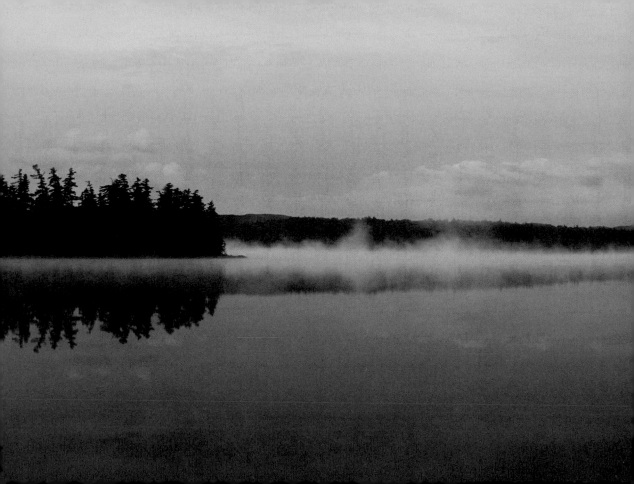

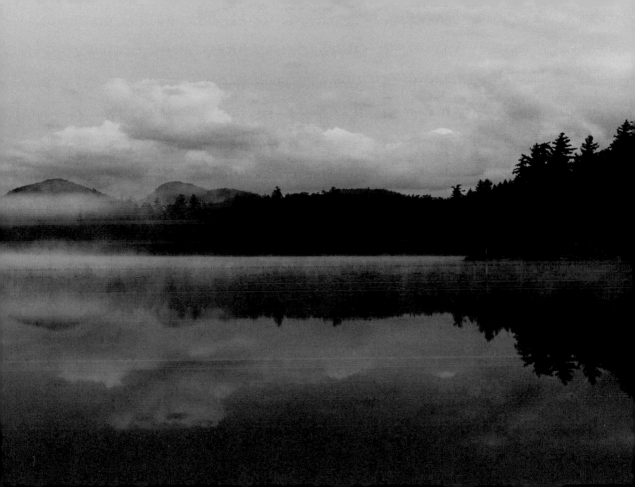

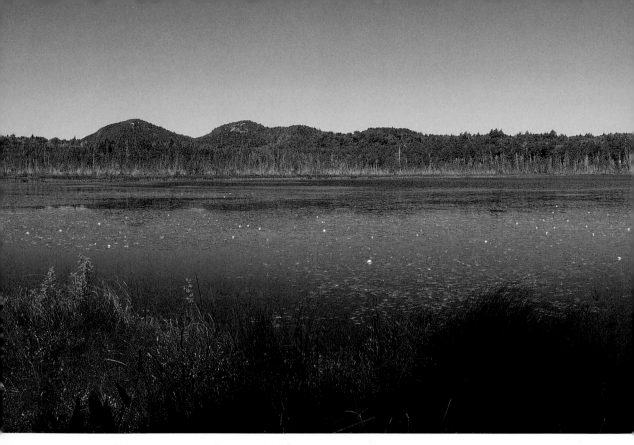

previous page *Twilight over Barnum Pond near Paul Smiths*

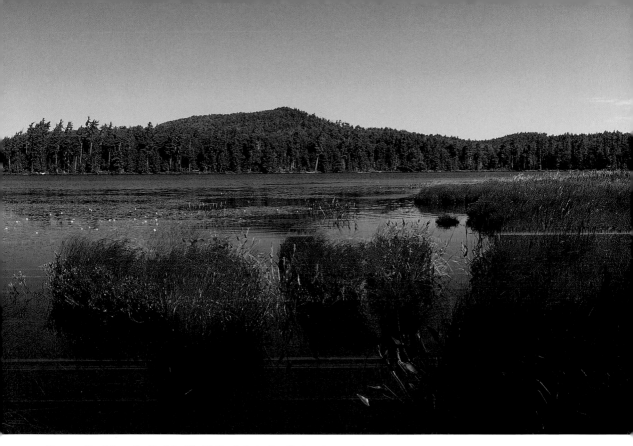

above *Barnum Pond from the Paul Smiths Visitor Interpretive Center*

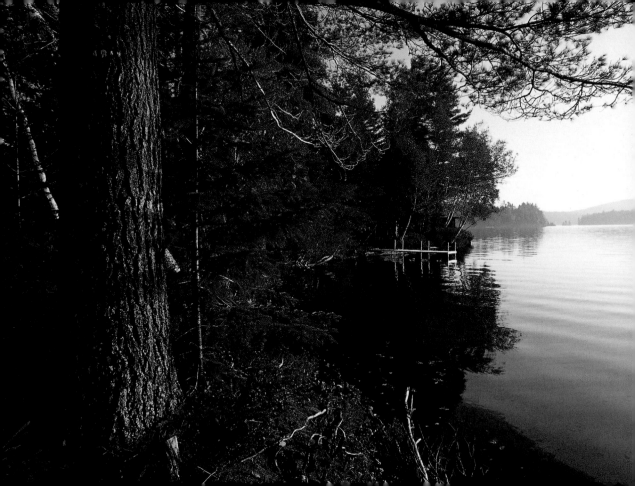

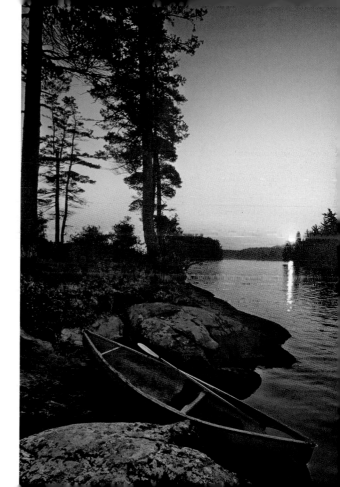

right *Dawn on Middle Saranac Lake*
opposite *Looking north on Upper Saranac Lake*

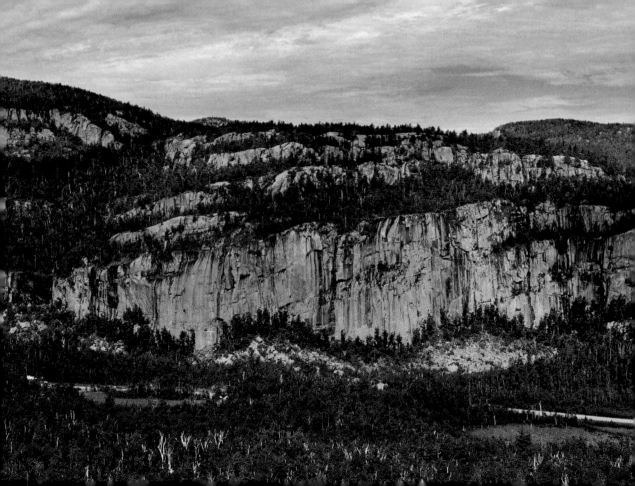

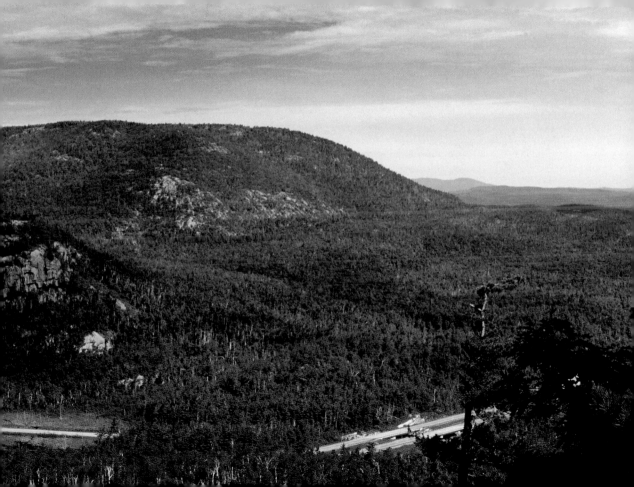

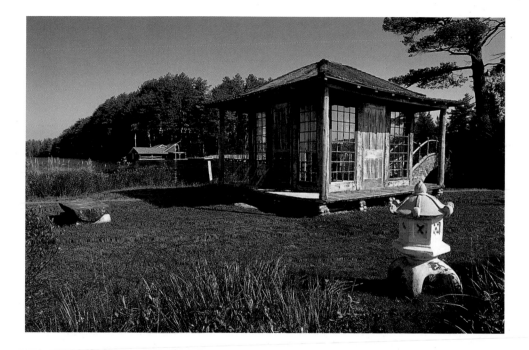

above *The gazebo at White Pine Camp, an Adirondack Great Camp on Osgood Pond* opposite *Black-eyed Susans and a log cabin just south of Clayburg* previous page *Poke-O-Moonshine and the Adirondack Northway* following page *The Adirondack Nature Conservancy's Silver Lake Bog Preserve boardwalk*

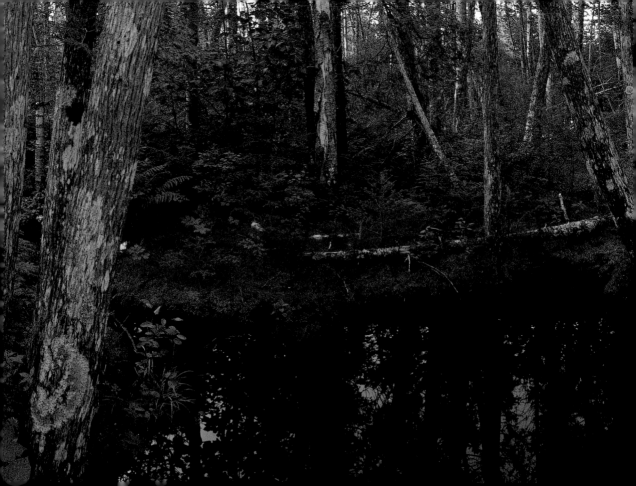

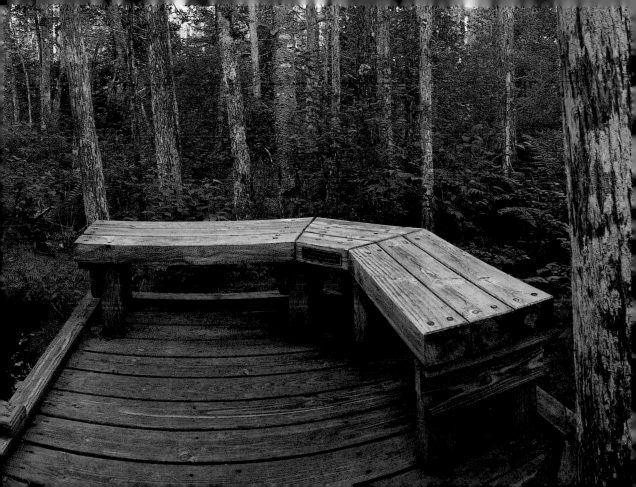

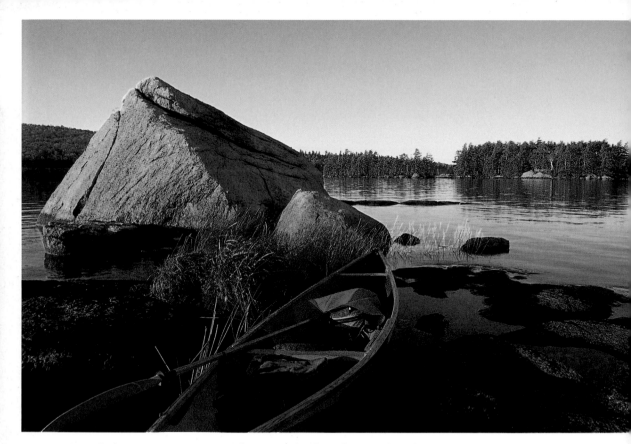

above *A Hornbeck canoe on Lower Saranac Lake* opposite *Church Pond near Paul Smiths*

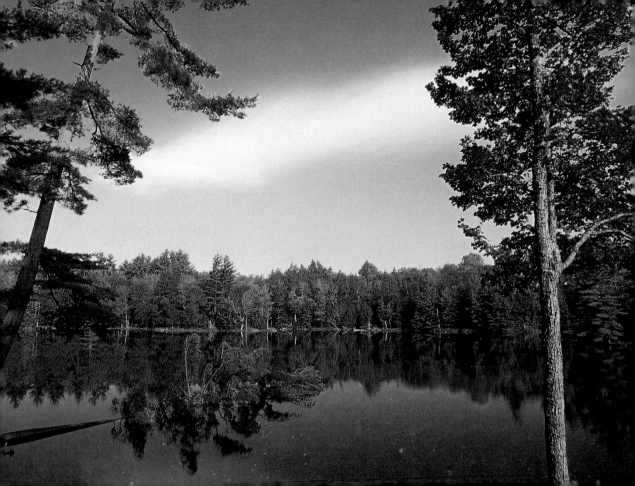

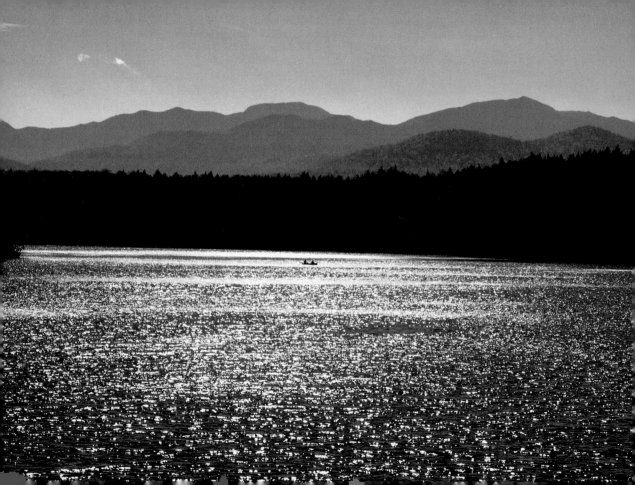

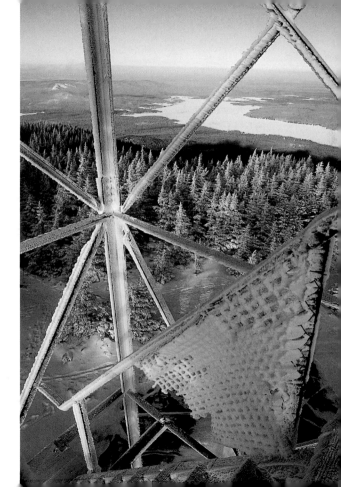

right *Rhime frost buildup on the Lyon Mountain fire tower*
opposite *Canoeing on Second Pond in the Saranacs*
following page *The view east and south over Chazy Lake and the northern Adirondacks from Lyon Mountain*

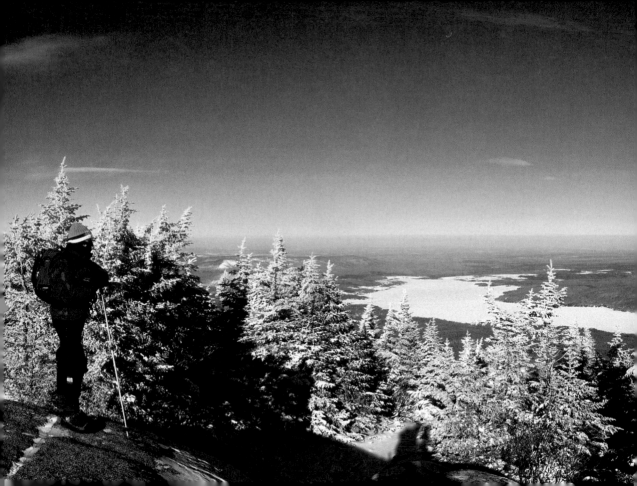

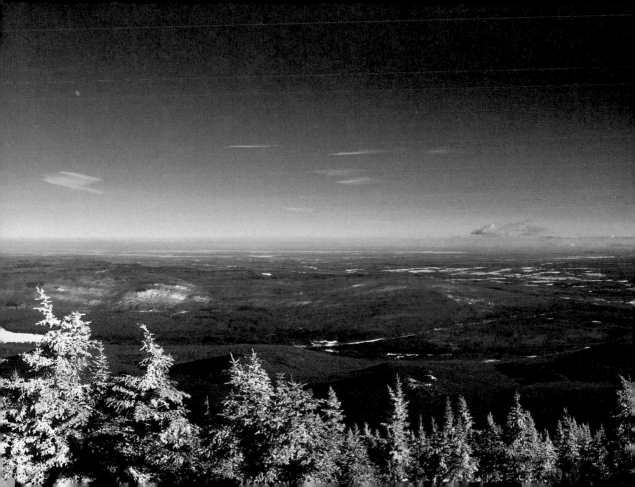

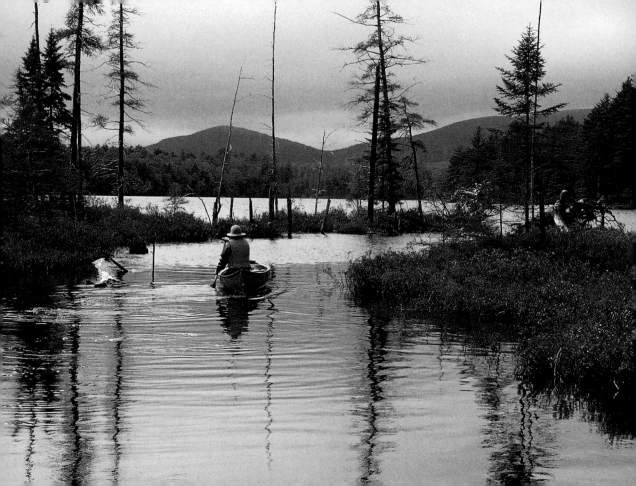

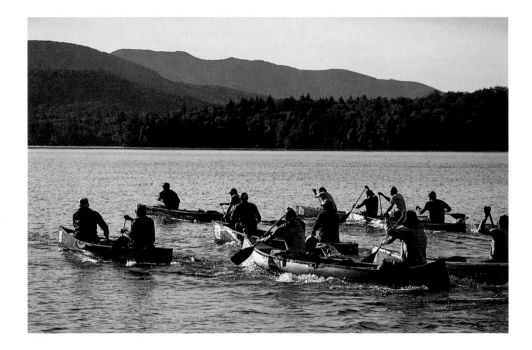

above *Upper Saranac Lake, the 90-mile Adirondack Canoe Classic* opposite *Canoeing on Saint Regis Pond*
following page *Silver Lake view from the Adirondack Nature Conservancy's Preserve*

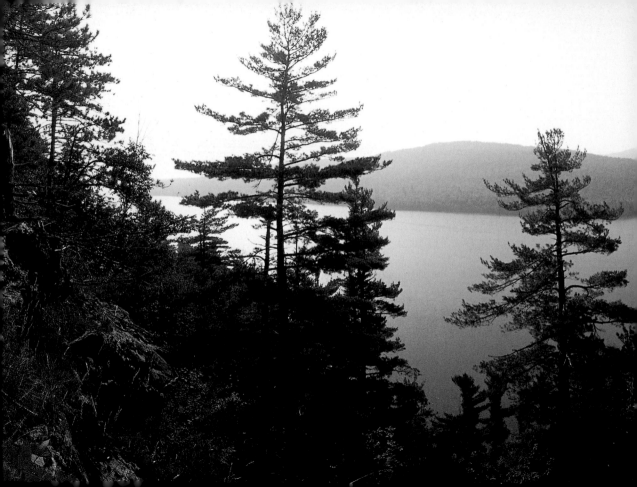

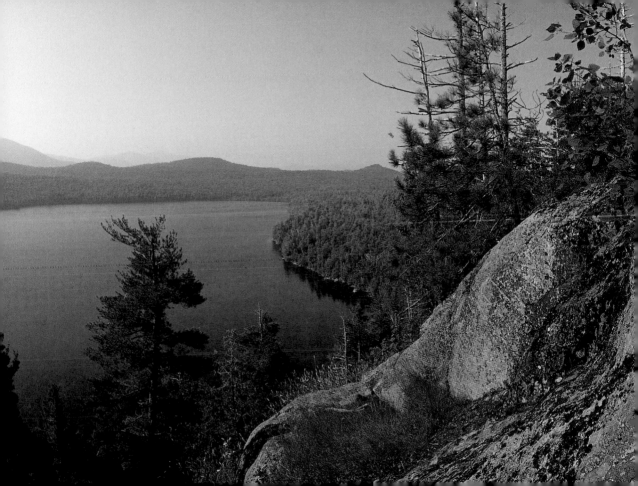

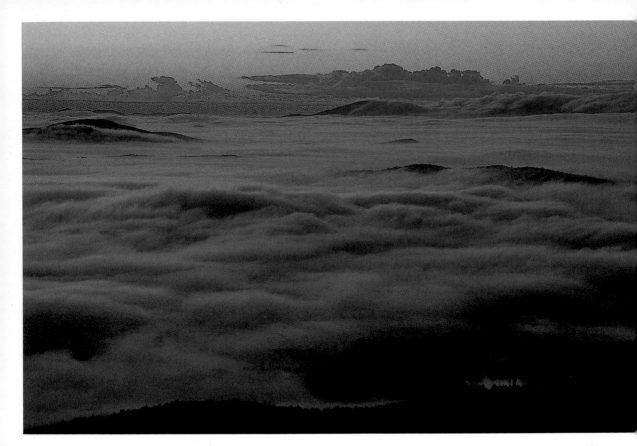

above *Morning twilight from Saint Regis Mountain*

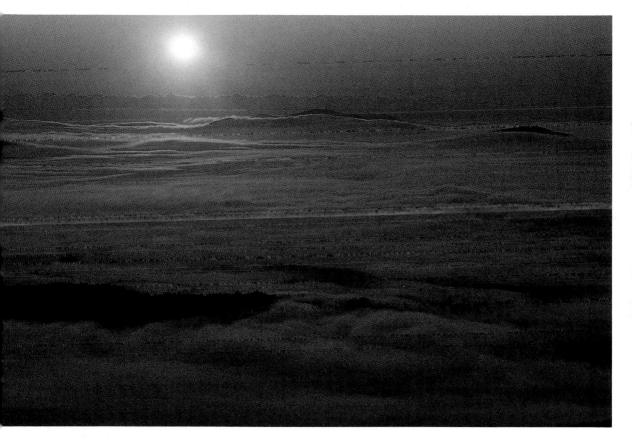

above *Sunrise from the Saint Regis Mountain fire tower* following page *Lower Saranac Lake and Saranac Lake village from Mount Baker*

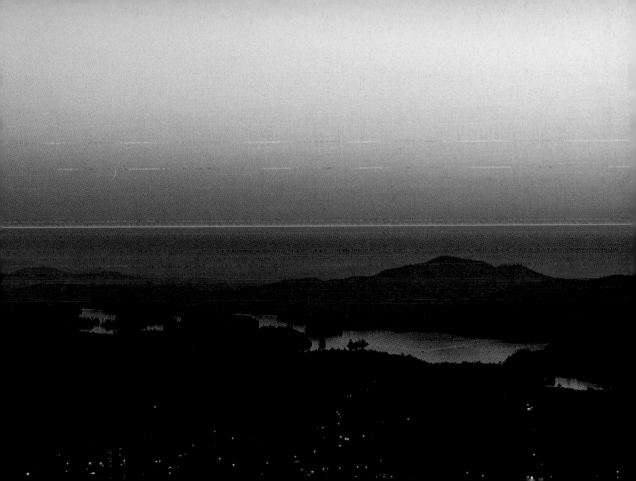

ACKNOWLEDGMENTS

FIRST, MANY THANKS TO Christopher Steighner and Charles Miers at Rizzoli for offering to publish this unique book of my Adirondack photography. Many thanks also to Sara Stemen for the wonderful design work that has created a sensitive flow to the image choices. During the thirty years I've been photographing the wonders of the Adirondacks, there are also many friends associated with different organizations in the region who have influenced and helped add new dimensions to my photography. I'd like to thank the Adirondack Mountain Club, the Adirondack Nature Conservancy, The Wild Center, the Adirondack Park Visitor Interpretive Centers, The Adirondack Council, the Adirondack Park Institute, the Association for the Protection of the Adirondacks, the Residents' Committee to Protect the Adirondacks, the Lake George Land Conservancy, the Lake George Association, the Fund for Lake George, the Adirondack Museum, the Adirondack Explorer, Adirondack Life, Great Camp Sagamore, Adirondack Discovery, the Open Space Institute, the Northern Forest Alliance, the Sierra Club, Crandall Library, NYS Department of Conservation, NYS Department of Economic Development, NYS Department of Transportation, Paul Smiths College, Frame of Mind galleries, regional arts groups, and my Adirondack folk musician friends—Dan Berggren, Dan Duggan, Peggy Lynn, Roy Hurd, Chuck Brumley, Karen Loffler, Chris Shaw, and Bridget Ball. All have played a part in defining the directions of my photography. Also, a very special thanks to my lifetime friends and especially my wife, Meg, and my family who have been a part of and supported my projects and photography business in more ways than can be imagined. And, this book would have never happened on schedule without the help of Jennifer Gibson in the office and especially the full-time help of my daughter, Greta, who runs the office when I'm on the road and whose expert knowledge of Photoshop and keen sensitivity to color tones and composition helps her digitally reproduce the beauty of the original scene from my film.

First published in the United States of America in 2006 by Rizzoli International Publications, Inc.
300 Park Avenue South
New York, NY 10010
www.rizzoliusa.com

© 2006 Carl Heilman II

2006 2007 2008 2009 / 10 9 8 7 6 5 4 3 2 1

Distributed in the U.S. trade by Random House, New York

Printed in China

ISBN-10: 0-8478-2790-9
ISBN-13: 978-0-8478-2790-9

Library of Congress Control Number: 2005937870